W9-AMR-833

W W R Bray

Dedicated to my father,
William Roland Tingey, MBE (1926–2008)

. .

Published by

Princeton Architectural Press

37 East Seventh Street

New York, New York 10003

For a free catalog of books, call

1.800.722.6657.

Visit our website at www.papress.com.

© 2010 Princeton Architectural Press

All rights reserved

Printed and bound in China

13 12 11 10 4 3 2 1 First edition

No part of this book may be used or
reproduced in any manner without
written permission from the publisher,
except in the context of reviews.

Every reasonable attempt has been
made to identify owners of copyright.
Errors or omissions will be corrected in
subsequent editions.

Editor: Sara Bader

Designer: Deb Wood

Special thanks to: Nettie Aljian,
Bree Anne Apperley, Nicola Bednarek,
Janet Behning, Becca Casbon, Carina
Cha, Tom Cho, Penny (Yuen Pik) Chu,
Carolyn Deuschle, Russell Fernandez,
Pete Fitzpatrick, Wendy Fuller, Jan
Haux, Linda Lee, Laurie Manfra, John
Myers, Katharine Myers, Dan Simon,
Andrew Stepanian, Jennifer Thompson,
Paul Wagner, and Joseph Weston of
Princeton Architectural Press
—Kevin C. Lippert, publisher

Library of Congress Cataloging-in-
Publication Data

Tingey, John, 1953–
 The Englishman who posted himself
and other curious objects / John
Tingey.
 p. cm.
 Includes bibliographical references.
 ISBN 978-1-56898-872-6
 1. Postal service—Great Britain—
History. 2. Bray, Willie Reginald, 1879–
1939. I. Title.
 HE6935.T56 2010
 383'.492--dc22

 2009048612

THE ENGLISHMAN

WHO

POSTED HIMSELF

AND OTHER

CURIOUS OBJECTS

JOHN TINGEY

PRINCETON ARCHITECTURAL PRESS, NEW YORK

7 FOREWORD
Zoë James

9 INTRODUCTION
An explanation of how the author came to delve into the strange postal activities of W. Reginald Bray

15 CHAPTER 1

The Origins of a Postal Pastime
The background of the world that Bray was born into and the developments in the postal system that sparked his curiosity

33 CHAPTER 2

Challenging Items—Skulls, Rhymes, Dogs, and Human Letters
His early experiments in testing what the Post Office would deliver and how far he could push the rules and regulations

83 CHAPTER 3

Postmarks—Where in the World?
How he succeeded in building up his diverse collection of postmarks without leaving home

107 CHAPTER 4

The Autograph King
The creation of the world's largest autograph collection, acquired entirely through the post

155 CHAPTER 5

Look at Me
Skilled in the art of self-promotion, Bray explored many means of publicising his activities, including publishing magazine articles and guest appearing on radio shows

167 AFTERWORD

169 ACKNOWLEDGMENTS

173 BIBLIOGRAPHY

175 IMAGE CREDITS

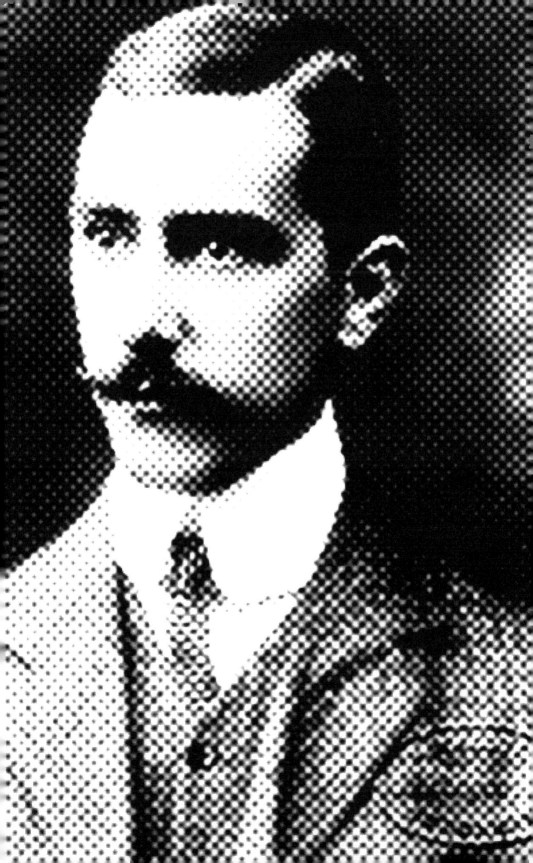

I am the granddaughter of Willie Reginald Bray. A man who never took a sick day in his life, he died of a massive heart attack at the age of sixty. His exploits, however, lived on in family folklore through his wife, Mabel (my grandmother), and his daughter, Phyllis (my mother), who both shared his zest for life, great sense of humour, and love of practical jokes.

We stored his large autograph collection, wrapped in brown paper and string, in the loft of our house in Surrey. These brown packages took up nearly half the storage space. When my grandmother died, my mother sold the bulk of the archive to a collector who had pestered her for years. Thankfully, she held on to about two hundred autographs of mostly film, theatre, and radio stars. (A huge ballet fan as a child, I became the keeper of Anna Pavlova's autograph.)

"Reg," as our family called him, had a great love of cycling around the English countryside. In 1905, he and five other friends set off on a spring cycling tour of Derbyshire and north Wales. It seems they visited many pubs and consumed much beer! It also appears that Reg found a way to integrate his postal experimentations into his cycling expeditions. "After a short interval whilst Willie wrote 27 postcards," one of the cyclists recorded in his diary, "we proceeded on our way."

Reg met my grandmother through the local cycling club in Forest Hill, now part of South East London. They also lived on the same street. My grand-mother was the middle of three sisters, and stories go that Reg courted all three at the same time, plus many other young women, until he finally proposed and married Mabel in September 1908. My mother, their only child, was born the following August. Reg worked full-time as an accountant and spent many hours of his spare time concocting postal curios and chasing autographs through the mail. Yet despite these preoccupations, which I imagine must have consumed many evenings and weekend afternoons, my mother considered him a loving and present father.

I have been privileged to share our family photos, autographs, and newspaper articles with John Tingey, and to contribute to his wonderful presentation of my grandfather's postal antics and autograph hunting.

—ZOË JAMES, BRISBANE, AUSTRALIA

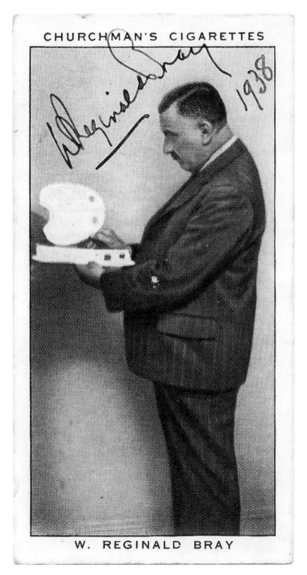

FIG. 1. This cigarette card was issued as part of a series of fifty cards featuring individuals who had appeared on the BBC radio programme *In Town Tonight*.

INTRODUCTION

At a stamp auction in Benson, Oxfordshire, in 2001, I bought a small group of strangely addressed postcards that travelled through the British post between 1898 and 1899. I collect old stamps and covers, and their quirkiness caught my eye.[1] Once I got them home, however, I couldn't work out exactly where they fit in with the rest of my collection and did what most collectors do in such circumstances: I put them in a drawer and promptly forgot about them.

A few years later my stamp club was having a show-and-tell meeting, and as I was scrabbling around trying to figure out what I could contribute, I came across these curiosities. The little stack included a couple of postcards with the addresses written in verse, a letter wedged into a bottle offering a reward to the finder if it were returned, several cards intentionally left on trains to be discovered and returned, two cards written to anonymous recipients, and one written in some sort of weird code. You can probably understand why they didn't fit neatly into a traditional stamp collection but perhaps not why I bought them in the first place.

The prospect of having to stand up in front of twenty or thirty club members and sound sufficiently informed motivated me to examine these items of mail more closely and mount them onto album pages with some descriptive information. By doing this, I learned that the same person, a certain W. R. Bray, created all of them. I wasn't quite sure how to describe them, so I put together a few pages under the general heading of "Bottle Mail," based on the fact that one of the items had been thrown into the sea enclosed in a bottle. Not particularly imaginative or clever, but it did seem to amuse my fellow philatelists. (Obviously we are very easily pleased.)

In 2004 I noticed a similar item, with the address also written in verse, for sale on eBay. I was intrigued to note that I did not own the entire output of W. R. Bray's strange pastime, but since that single item cost more than the amount I paid for my entire Bray collection, I ignored it. That was a very stupid decision. Two years later I spotted another peculiar object on eBay, a plain postcard addressed by placing a small cigarette card (a trading card from a cigarette package) on the front instead of the name of the intended recipient. The identity of the person featured on the cigarette card wasn't immediately

1 *In stamp collecting terms, a cover is an envelope or wrapper usually still bearing the original stamps.*

obvious, but after a bit of detective work I managed to ascertain that it was Edward James Saunderson, a well-known Irish politician. The message on the back asked for the card to be autographed by the person featured in the photograph and returned to, you guessed it, W. Reginald Bray! At least I had solved the mystery of the initial R. Little did I realise what a profound impact that purchase would have on my life.

I decided to find out more about the person who sent these odd items. All I knew was the scant information I could glean from the cards: his name and the fact that he lived in Forest Hill, Kent, between 1898 and 1901. Easy, I thought, there is bound to be plenty of information about him on the Internet. After trying myriad search-term combinations, in May 2007 I finally came across a single page on the community website for Sydenham in Lewisham, a borough of London. Eureka! There was my man, with a brief description of his hobby and, joy of joys, an image of a cigarette card showing him holding a couple of unusual objects. » [FIGS. 1-2]

I quickly struck up an email conversation with the webmaster, who generously sent scans of his own collection of Bray postcards. Now officially hooked, I decided to set up my own website dedicated to Bray's postal activities. I also came across a one-page cartoon about Bray drawn by Michael Leigh, a mail artist, originally published in an anthology in 1989. After an exchange of emails, he kindly agreed to sell the original to me, which now sits proudly in my collection. Soon after, I spotted another nice piece on eBay, described as a hand-illustrated puzzle card sent to an unknown address in London. I recognised it immediately as one of Bray's creations. After decoding the address, which consisted of words and pictures, I learned that his friend Ernest Arnold was the intended recipient. (You will hear more about Arnold in the following chapters.) Needless to say, I snapped up the card.

So far, so good, but progress was slow, and I was only managing to add the occasional item to my collection and website. The second breakthrough came in June 2007, when a stamp-collecting colleague and I attended a large postcard fair in Reading, Berkshire. We visited every dealer in search of more Bray cards. Alas, the vast majority of dealers denied any knowledge of my man, whilst the knowledgeable few informed me that Bray cards were quite scarce

and that they hadn't offered any for sale in years. How depressing; that is, except for one dealer who offered three cards for sale and apparently owned another stash at home. After a brief negotiation, I agreed to buy them all sight unseen and left the fair clutching three of my new treasures.

Imagine my delight when a package soon arrived containing dozens of cards, most of them autographs of famous and not-so-famous people who lived in the early twentieth century. From these cards, I pieced together more information about Bray; in particular, the four different addresses where he lived between 1898 and 1939. I suspected that this would be about as far as I would get and resigned myself to picking up the occasional card on eBay or at stamp and postcard fairs.

Not so. The final, most significant development came when, in July 2007, I received an email from the Sydenham webmaster reporting that Bray's granddaughter, Zoë James, who lives in Australia, contacted him. She came across my website and was delighted to find that people are actively interested in the postal activities of her grandfather. We began emailing each other regularly, and she provided me with invaluable background information, family photos, and scans of the cards she inherited from her mother. One interesting new tidbit of information: her grandfather had been christened Willie Reginald Bray; his first name was not William, as I previously assumed. Apparently he had taken a dislike to "Willie" at a very early age and was known as "Reg" or "Reggie" to his friends and family, but as "Reginald" to the outside world. She also shared the contents of her grandfather's scrapbooks full of newspaper cuttings and letters chronicling his activities.

Since then, my quest has continued. I've met Bray's great-grand-daughter, Nicola James, who lives in England, and had the chance to look through her own collection of cards, newspaper articles, and letters. She visited me recently, and we had a good old chat about Reginald.

This book is not designed to be an educational tome about philately, postal history, or postcards; rather, it is intended as an exploration of the intriguing hobby of a rather eccentric Englishman in the late nineteenth and early twentieth centuries. I've assembled this story by studying his postal items; reading a number of magazine articles he wrote, as well as the contemporary

newspaper coverage of him by others; and listening to the family history shared by his descendants. You can find more visuals on my website at www.wrbray.org.uk. I would be delighted to hear from anyone who can supply new information or images. So far I have managed to track down only a few hundred of the more than thirty-two thousand curios and autograph requests he sent over the years. There are many more out there yet to be discovered.

ALBUMS FOR CHURCHMAN'S PICTURE
CARDS CAN BE OBTAINED FROM
TOBACCONISTS AT ONE PENNY EACH

"IN TOWN TO-NIGHT"

A SERIES OF 50

6

W. REGINALD BRAY
The Human Letter

The owner of the largest collection of postal curios in the British Isles, Mr. Bray was the first man to post himself as a human letter. His collection was started as a hobby in 1898; he made a thorough study of the Post Office Guide and discovered that one of the smallest articles that can be sent by post is a bee, and the largest an elephant! Mr. Bray has posted many peculiar articles, including a shirt front and a collar with the addresses actually written upon them (see illustration). Other things he has sent include a bowler hat, a turnip with the address and message carved on it, a pipe, cigarette, flask, shoes, cycle pump, etc.

W.A.& A.C.CHURCHMAN

ISSUED BY THE IMPERIAL TOBACCO CO.
(OF GREAT BRITAIN & IRELAND), LTD.

FIG. 2. The reverse
side of the Churchman's
cigarette card describes
Bray's postal legacy.

The Origins of a Postal Pastime

It could be argued that the story of Willie Reginald Bray started on April 30, 1879, when Edmund and Mary Bray became the parents of a baby boy. However, perhaps the real beginning came nearly forty years earlier, when the UK's Post Office introduced the revolutionary uniform penny postage.

For years a postal reformer named Rowland Hill had lobbied the Post Office to radically overhaul the system to make it more affordable for the general population and, in turn, more lucrative for the government. By analysing the actual costs of carrying letters from London to Scotland, he proved that reducing the expense of posting a letter would increase demand and profits. Prior to the reform, both the item's weight and the distance travelled influenced the postage charges, with the receiver usually carrying the burden of the costs, instead of the sender. Imagine how you would feel if the postman asked you to pay for all the junk mail you receive every day! Hill's pressure changed the system: in 1840 all letters weighing up to half an ounce could be delivered anywhere in the British Isles for 1d. (one penny), with the cost of that postage prepaid by the sender.[1]

To simplify this prepaid system, the Post Office introduced adhesive labels (stamps), which could be purchased at the cost of 1d. and 2d. These are the Penny Black and Two Pence Blue, now famous in the world of philately. » ⌈FIG. 3⌉ To coincide with the introduction of the stamps, the Post Office also sold prepaid 1d. and 2d. stationery that could be bought at a premium of a farthing, not including postage costs.[2] Designed by the artist William Mulready, these envelopes and letter sheets featured an elaborate illustration depicting Britannia despatching mail to all four points of the compass. » ⌈FIG. 4⌉

The British public derided the overtly patriotic design of these Mulreadys, as they came to be known. Poor sales and unsold stock prompted the Post Office to withdraw the envelopes in 1841 and introduce new, plainer letter sheets in 1844. The public, though,

1 *Prior to decimalisation in 1971, there were twelve pennies (12d.) in one shilling and twenty shillings in one pound sterling.*

2 *A farthing was a quarter of a penny.*

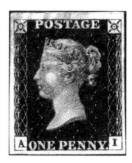 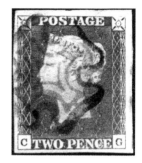

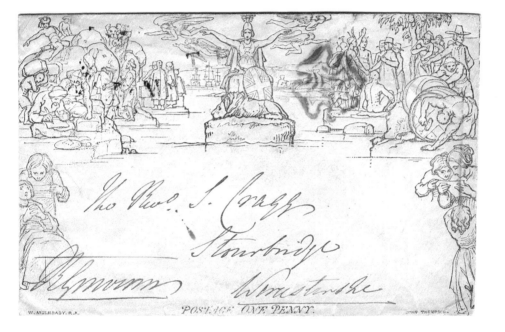

FIG. 3. The world's first postage stamps bear a design based on the head of Queen Victoria as it appeared on engraver William Wyon's City Medal of 1837. The brilliant simplicity of the design is still reflected in today's stamps.

FIG. 4. On this one-penny prepaid stationery envelope designed by William Mulready, the centre of the design features Britannia sitting on a lion and holding a shield depicting the Union Jack.

COLLECTION OF THE AUTHOR. STAMP DESIGNS © ROYAL MAIL GROUP LTD. REPRODUCED BY KIND PERMISSION OF ROYAL MAIL GROUP LTD. ALL RIGHTS RESERVED.

continued to mock the now-defunct Mulreadys. A cottage industry sprang up, with private companies printing a variety of caricatures of Mulready's design. » [FIG. 5] At the same time, more serious illustrated envelopes emerged bearing designs that promoted popular issues of the day, such as peace, temperance, antislavery, and universal penny postage. » [FIG. 6] Not to be outdone, individuals got in on the act, using artistic skill to produce highly decorated hand-illustrated envelopes to send to friends and loved ones. » [FIG. 7] Commercial companies recognised the marketing potential of the post and produced a wonderful range of envelopes advertising their products and services. » [FIG. 8] All of these types of illustrated envelopes are considered the beginnings of mail art, which can be loosely defined as art that uses the postal system as its medium. It is entirely possible that these early items of mail art helped plant the seed of curiosity in Bray's mind concerning what could be legitimately carried through the post.

The Brays lived in a modest Victorian villa on Stanstead Road in Forest Hill. Edmund's half-brother, Mark Duffett, half-sister, Lizzie (aka Ada) Duffett, and their mother, Elizabeth Duffett, also lived there.[3] » [FIG. 9]

At the age of ten Bray began attending St. Dunstan's College, a fifteen minute walk away. In 1893 he was awarded a certificate for Latin but otherwise seems to have had a fairly undistinguished academic career.

Although central London was readily accessible by train for Bray and his friends, there was much to occupy a teenager within a few minutes of home. The major attraction was the Crystal Palace originally designed by Sir Joseph Paxton to house the Great Exhibition of 1851. During Bray's childhood, it served as a venue for concerts,

3 *Today, Forest Hill is a populous suburb in South East London, little-changed from the Victorian suburb that Bray's newlywed parents moved to in about 1878. After the London & Croydon Railway opened in 1839, the second passenger railway to open in the London area, Forest Hill became a commuter suburban area of open countryside, farmland, wooded hills, and lanes and yet only a short journey from the capital. Instead of a couple of hours' ride by horse and carriage, it became possible to travel to London in less than twenty minutes.*

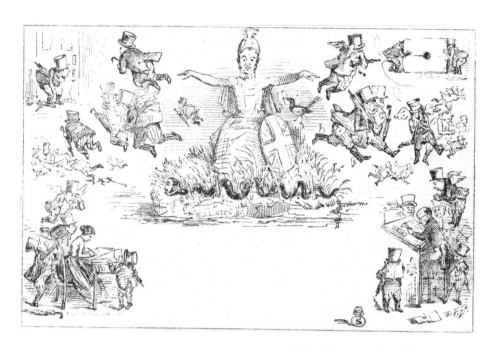

FIG. 5. This caricature envelope satirises the fact that the Post Office was opening letters written by, and sent to, suspect persons. The design depicts the Home Secretary, Sir James Graham, flanked by representations of Paul Pry, a fictional character, looking into the affairs of citizens.

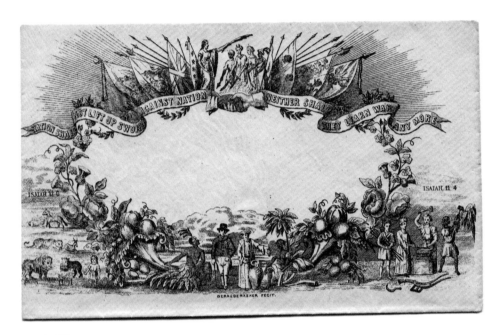

FIG. 6. This
nineteenth-century
propaganda envelope
promotes the cause of
peace between nations.

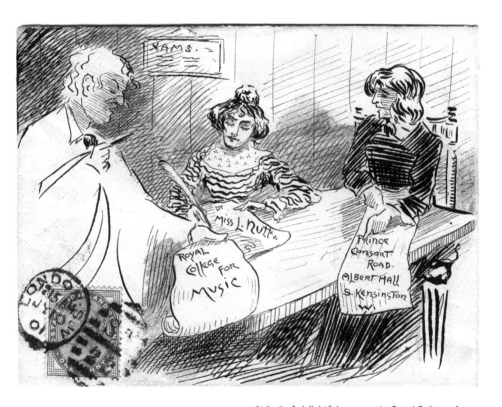

FIG. 7. A delightful envelope—posted on July 10, 1901—bears an expertly hand-drawn picture of a teacher presiding over two students taking their exams, presumably at the Royal College of Music. Note the way that the name and address of the recipient have been incorporated into the drawing.

FIG. 8. Posted on
January 17, 1897, a
commercially produced
illustrated envelope
advertises the products
of S. Griffiths, an
engineering firm based
in Wednesfield in the
West Midlands. The
design depicts a fairly
vicious-looking trap and
the company logo.

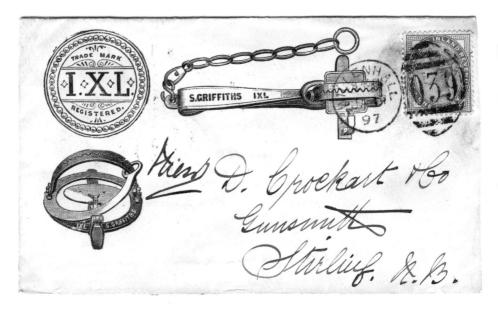

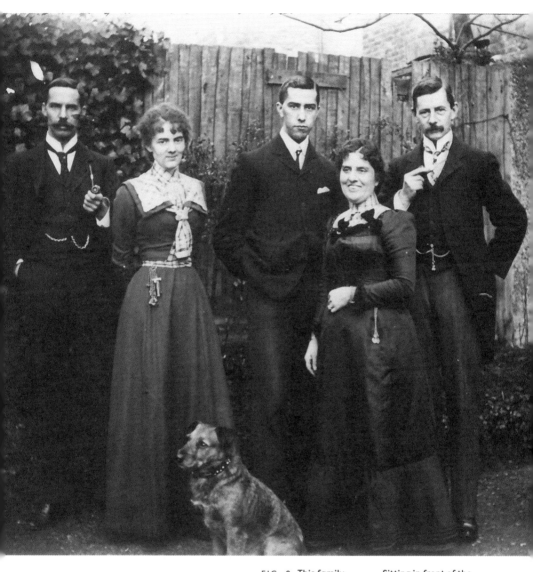

FIG. 9. This family photo was taken in 1900 in the garden of their house on Devonshire Road. In the group are (left to right) Mark Duffett (uncle), Ada Duffett (aunt), Reginald, Mary Bray (mother), and Edmund Bray (father). Sitting in front of the group is the brave dog that Reginald posted that year.

plays, and art exhibitions, as well as lighter entertainment, such as pantomimes, gymnastics, sporting events, spectacular firework displays, ice-skating, brass bands, and circus events. In 1885 Forest Hill Swimming Pools opened on Dartmouth Road, and nearby Forest Hill Library opened in 1901. Bray likely found the library particularly useful, especially the reference section.

All in all, his upbringing was fairly ordinary for a middle-class boy in the late nineteenth century. » [FIG. 10] But during his formative years, he had already developed a passion for collecting postage stamps and postmarks—the nascent beginnings of his fascination with the postal system. He also collected train tickets (and girlfriends). He was a keen cyclist and would often go on cycling holidays with friends, which proved useful in the pursuit of his hobbies, especially the pursuit of female companionship. » [FIG. 11]

1898 turned out to be a pivotal year in Bray's life, for it was then that he decided to purchase a copy of the *Post Office Guide*, a large reference book published quarterly by the Post Office, detailing its services, costs, and regulations. » [FIGS. 12-13] The guide could be bought at any Post Office for the princely sum of sixpence and offered a veritable mine of information for an enquiring mind. What inspired him to read such a weighty tome is unclear, but in it he discovered a few paragraphs that sparked his imagination.

> *Letters, book packets, postcards, and newspapers are not liable to additional postage for re-direction, whether re-directed by an officer of the Post Office or by an agent of the addressee after delivery, provided in the latter case that the letters, etc., are re-posted not later than the day (Sundays and public holidays not being counted) after delivery, and that they do not appear to have been opened or tampered with. Re-directed letters, [etc.], which are re-posted later than the day after delivery will be liable to charge at the prepaid rate. Any which appear to have been opened or tampered with will be chargeable as freshly posted unpaid letters or packets.*

FIG. 10. This 1891 photograph of Bray shows him at age twelve, dressed in his Sunday best.

FIG. 11. In a 1904 photograph, Bray (second from the left) and his friends pose with their treasured bicycles.

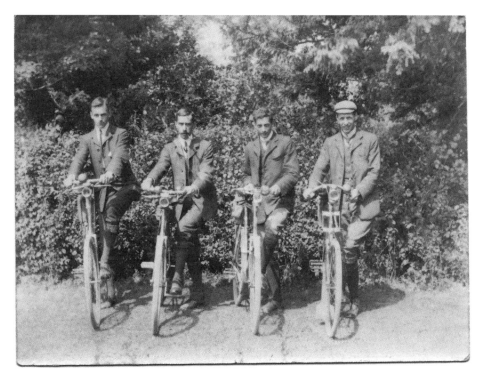

NOTICE TO THE PUBLIC.

POST OFFICE PUBLICATIONS
NOW READY.

NEW QUARTERLY ISSUE OF THE

POST OFFICE
GUIDE

Published 1st October, Price 6d

ALSO

NEW HALF-YEARLY ISSUE OF THE

POST OFFICE
HANDBOOK

Published 1st July, Price 1d.

Printed for H. M. Stationery Office by W. P. GRIFFITH & SONS, Ld., Prujean Square, Old Bailey, E.C.

Addressing Correspondence.

8. Letters, &c., should be clearly and legibly addressed. When writing to a place where there is a *Sub-Post Office only*, the name of the *Post-town* (or *County* in some cases) should be added.

The name of the Post-town, as a rule, completes the address, but in certain cases the name of the *County* is required.

Abbreviated addresses registered for Telegrams cannot be used for letters.

9. In the case of letters or other postal packets for places abroad the name of the *country* as well as the town should be given in full. For example, a letter intended for London (Ontario) should be so addressed.

Reading further he learned that "letters, [etc.], should be clearly and legibly addressed" and that "all letters, [etc.], must be delivered as addressed."

Bray viewed these rules as challenges, opportunities to determine how far the Post Office would go to comply with its own regulations. He must have brought his copy of the *Post Office Guide* with him when, a year later, in 1899, his family and the Duffetts all moved from 155 Stanstead Road to a new home at 135 Devonshire Road. He didn't have to walk far to reach the nearest mailbox: a Penfold pillar-box stood, and still stands, right outside the front door of that house.[4] No doubt this was the box where Bray dropped thousands of cards and strange objects over the next ten years.

He created his most elaborate curios, such as the rabbit's skull and the turnip, while living on Stanstead Road. By 1909, at age thirty, when he left his family's home and moved to 13 Queenswood Road with his new wife, Mabel, Bray's focus had changed. » [FIG. 14] Instead of engaging in complicated postal experiments, he spent his energy building the world's largest autograph collection entirely through the mail. The arrival of their first and only daughter, Phyllis, and his day job as an accountant do not appear to have slowed his efforts. » [FIG. 15]

4 *A pillar-box is equivalent to the American mailbox. A Penfold is named after its designer, J. W. Penfold.*

FIG. 12. (OPPOSITE) This 1898 poster advertises the latest issue of the *Post Office Guide*, the handbook that initially inspired Bray.

FIG. 13. (ABOVE) An extract from the *Post Office Guide* explains the proper way to address correspondence.

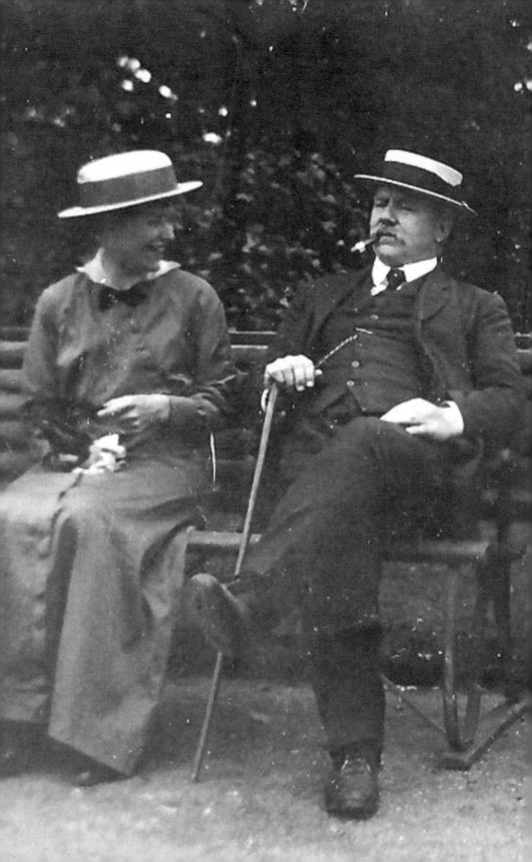

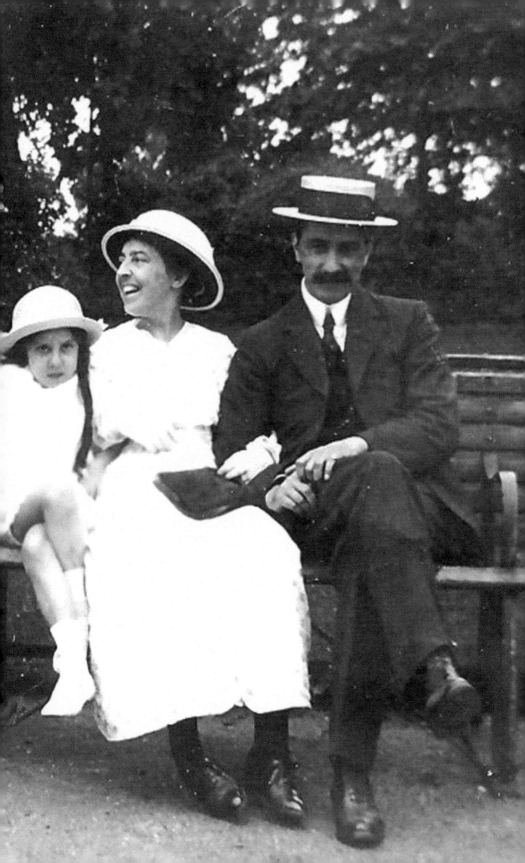

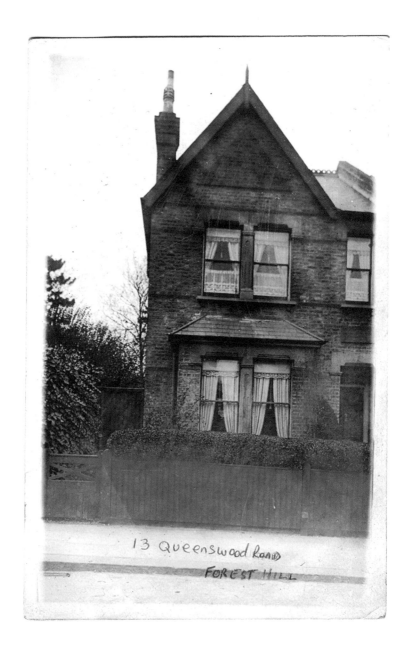

His meticulous record keeping made it possible for him to keep track of the thousands of information and autograph requests he sent out and received. By 1903 Bray was assigning each curio and autograph request a unique number and painstakingly recording the details in a register. An accountant's attention to accuracy and detail likely inspired such thorough record keeping. Although that register has not resurfaced, after being sold with the rest of the collection, the registration numbers track the order of his unusual endeavours over time.

Sequencing the cards and autographs from Bray's collection presented me with an organisational challenge. His creative approaches both varied and overlapped: at any one time he could be posting root vegetables, casting bottles into the sea, and pestering Boer War generals for their autographs. In order to convey a sense of Bray's diverse, far-reaching postal activities, I chose to structure the book by what he set out to accomplish, rather than by the strict chronological order of his cards and curios.

FIG. 14. (OPPOSITE) A photograph of Bray's house at 13 Queenswood Road in Forest Hill, where he lived from 1909 to 1912.

FIG. 15. (PREVIOUS SPREAD) Phyllis, Mabel, and Reginald Bray share a joke with an older couple in 1915.

Challenging Items—Skulls, Rhymes, Dogs, and Human Letters

*Some time ago it occurred to me to venture on the post office
authorities a number of letters, curious both in form and
address. This course I did not enter upon without much
consideration and hesitancy, for it would be most unfair, to
say the least of it, to cause a lot of unnecessary trouble, merely
for the sake of playing a senseless prank. My object from the
beginning was to test the ingenuity of the postal authorities,
and, if possible, to vindicate them of the "charges of
carelessness and neglect." Should these lines come before the
eyes of any official through whose hands my "trick letters"
have passed, I hope he will accept this explanation as an
apology for any extra trouble that I may have caused him.*

—"Postal Curiosities," *Royal Magazine*, 1904

So it was that Bray first explained how and why he set out to test the
regulations of the Post Office. Without a doubt, the most provocative
of his "trick letters" are the many objects that he sent through the
mail without any form of protective wrapping. Bray simply stamped
and addressed these items, and dropped them in a pillar-box for
subsequent delivery back to himself. » [FIG. 16] By their very nature,
many of these objects have all but disappeared into history. Who,
after all, would want to keep a rabbit's skull, and I'm sure that he
still had need of his bicycle pump and frying pan. » [FIG. 17] Bray
considered the rabbit's skull to be his most gruesome curio. He wrote
the address along the nasal bone and placed the stamps on the back.
A purse was perhaps his most devious puzzle to solve: he wrote the
address and placed the stamp inside before closing and posting it.
There was no evidence that it was a letter until the collector opened
it (possibly looking for a few coins) and noted the contents inside.
The postal carrier delivered it the next day. The turnip, sadly, has
long since shrivelled away to nothing, and someone likely smoked the
Russian cigarette over one hundred years ago. » [FIG. 18] The local
post collector must have been both intrigued and slightly apprehensive
about what he would find when he opened the pillar-box each day.

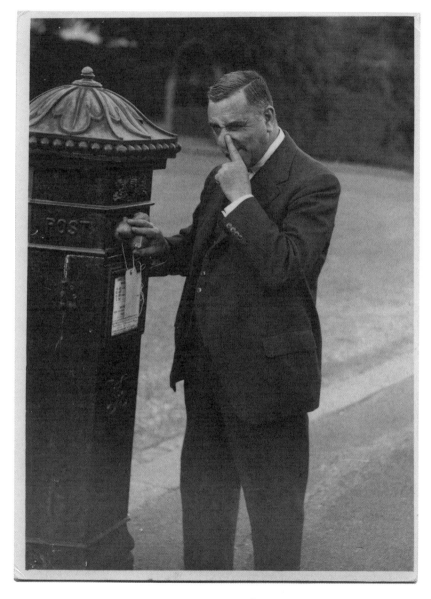

FIG. 16. Bray reenacts the time he posted some onions, in this photo from 1932. Note the luggage label attached to the vegetables, on which his name and address are written.

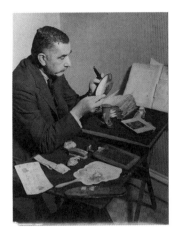

FIG. 17. (LEFT)
In a 1932 photograph, Bray sits at a table and studies some of the items he sent through the post some thirty years earlier. Amongst them are a slipper, a clothes brush, a pipe, a shirtfront, a shirt collar, and a drawing slate.

FIG. 18.(BOTTOM)
Bray (second from the left) poses outside the Post Office at Slyne Head, Ireland, where he dug up a turnip and subsequently posted it back to himself in 1900.

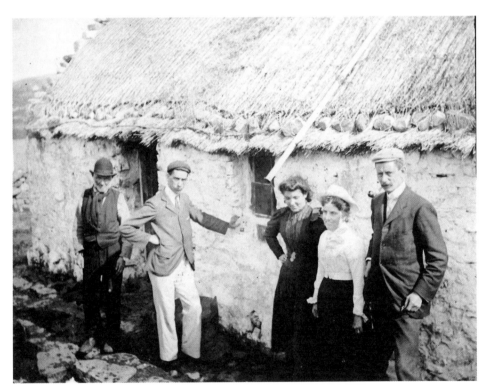

Thus far, only two such objects have come to light: a piece of seaweed attached to a postcard; and an old-fashioned one-penny coin, with a hole drilled into it and a label attached, upon which Bray wrote his address and placed the requisite postage stamp. » [FIGS. 19–20]

Slightly less strange, but still rare and fascinating, are the envelopes and cards he manufactured out of the unlikeliest of materials. In January 1899 he cut up a shirt collar, starched it, and created two postcards that he duly posted: one to his friend Ernest Arnold and one to a Mr. Southern, both in London. Although the first of these passed through the post without a hitch, the carrier deemed the second "contrary to regulations" and returned it with an excess fee of one penny. » [FIGS. 21–22] The following month he repeated the feat, this time with a piece of starched shirt cuff. » [FIG. 23] In July Bray sent two cards cut into very distinct shapes. The first was a cartoon of a man's head. » [FIG. 24] The other was the head of a donkey with "Mr" written above its open mouth. » [FIG. 25]

His long-suffering mother, Mary, did not escape involvement in her son's postal activities. In October 1899 he persuaded her to crochet an envelope with the simple address, "Bray, Forest Hill." To this she sewed a small piece of card on which she affixed two halfpenny stamps. The Post Office delivered the envelope without any objection. » [FIG. 26] The following year Mary crocheted a more elaborate affair, which her son posted to Annie Tayler at Shelly Hall, a young lady he admired and one reason he enjoyed his visits to Suffolk. » [FIG. 27] There are illustrations from old magazine articles and family photographs that show what some of the other objects looked like.

Bray played with the shapes and materials of his postal curios, but he also toyed with the "ink" with which he wrote out the addresses. One such experiment—a card addressed in red sealing wax—turned

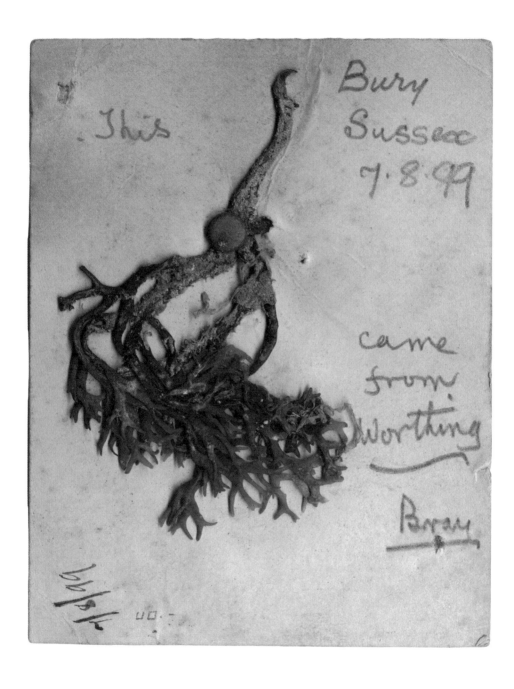

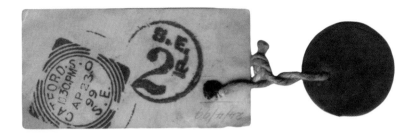

FIG. 19. (OPPOSITE)
Attached to this post-
card is a small piece
of seaweed scavenged
from the beach at
Worthing.

FIG. 20. (ABOVE)
This coin arrived
at Bray's home on
Devonshire Road the
day after he posted it.
Unfortunately, it

appears that he forgot
to stick a stamp on the
label, so the Post Office
charged him 2d. for
the unpaid postage.

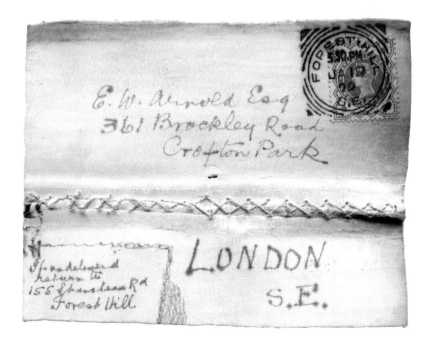

FIG. 21. Bray made
this postcard from two
pieces of a starched
shirt collar sewn
together. He sent it
to Ernest Arnold with

a message on the
back referring to his
broken arm. Bray was
despatched to Shelly
Hall to recuperate a few
days later.

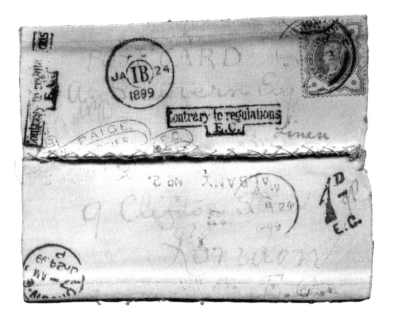

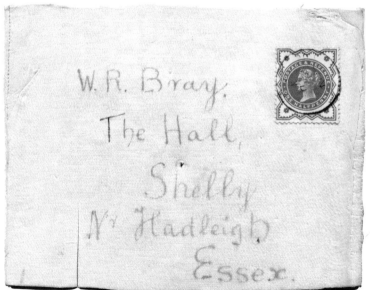

FIG. 22. (TOP) A second card made out of the same shirt collar was addressed to a Mr. Southern. For some reason the Post Office took exception to this card and identified it as a letter instead of a postcard and charged Bray extra for it.

FIG. 23. (ABOVE) Made out of a starched piece of shirt cuff, Bray sent this card to himself whilst he was staying at Shelly Hall.

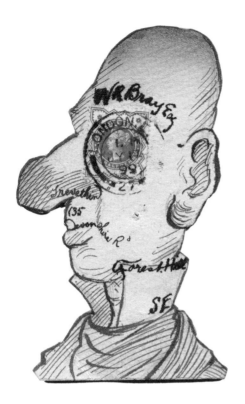

FIG. 24. Bray cut a postcard into the shape of a cartoon man's head, likely based on the popular comic character Ally Sloper.

FIG. 25. Another postcard formed the shape of a braying donkey's head.

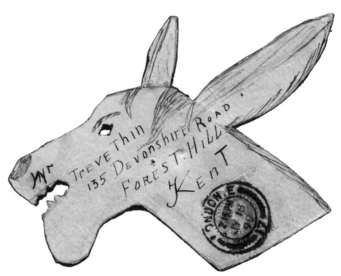

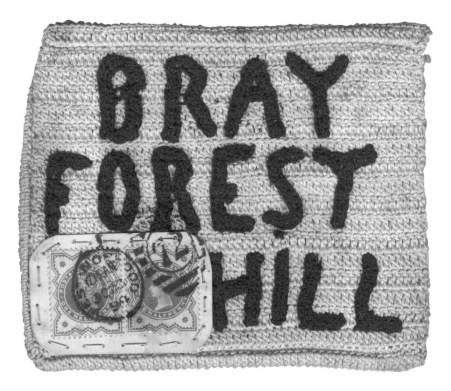

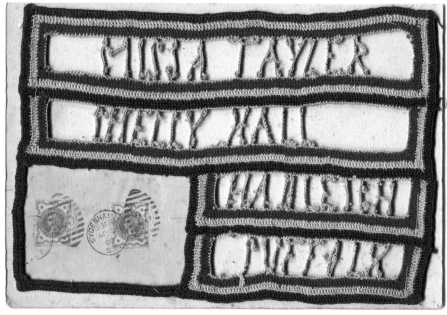

out to be a spectacular failure. He didn't anticipate that much of the wax would part company with the card, falling away in transit and rendering the address totally illegible. Needless to say, the Post Office returned this one undelivered. ›› ⸤FIG. 28⸥

Postal historians would probably consider Bray's early attempts to confound the Post Office with strangely addressed postcards his most interesting and ingenious efforts and, therefore, his most significant. Indeed, a number of eminent philatelists proudly boast some early Bray ephemera in their collections of peculiar items, or underpaid and redirected mail. The earliest I have seen of these is a postcard sent on June 28, 1898, to Arnold, who was staying in Ivybridge, Devon, at the time. Bray sent a number of early curios to Arnold, a neighbour for several years and old friend. This time, instead of using the normal method of address, Bray wrote his friend's address in verse:

> *Now Postman be kind if you will*
> *Deliver this down at "Torrhill"*
> *This house is situate in Devon*
> *The post went out about eleven*
> *The Post Office is down in the village*
> *The name of which is Ivybridge*
> *The address I think I've now you told*
> *Except the name is E. Arnold.*

Because he underlined the relevant words of the rhyme, the Post Office deemed the card validly addressed and duly delivered it. On the back Bray wrote a message to Arnold instructing him to bring the card back to Forest Hill on his return home. ›› ⸤FIG. 29⸥

FIG. 26. (OPPOSITE, TOP) An envelope crocheted by Bray's talented mother, Mary.

FIG. 27. (OPPOSITE, BOTTOM) This crocheted address is also Mary Bray's handiwork. Apart from the small piece of card sewn onto the bottom left-hand corner, this item was sent through the post without protective wrapping and arrived at its destination undamaged.

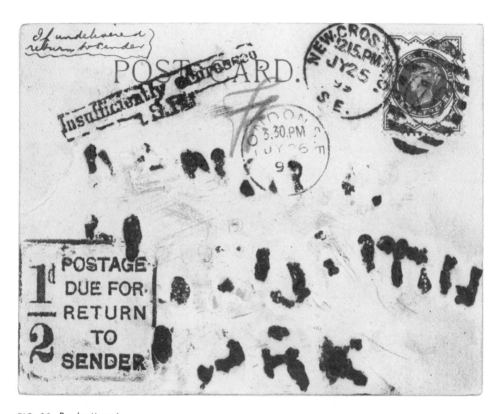

FIG. 28. Bray's attempt
to write an address in
sealing wax was returned
with an "insufficiently
addressed" cachet.

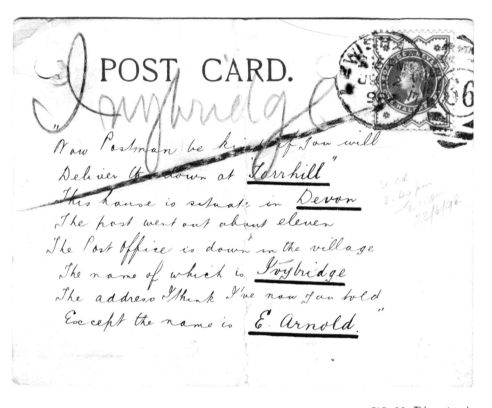

POST CARD.

Now Postman be kind if you will
Deliver it down at "Torrhill"
This house is situate in Devon
The post went out about eleven
The Post Office is down in the village
The name of which is Ivybridge
The address I think I've now you told
Except the name is E. Arnold."

FIG. 29. This postcard, sent to Arnold with the address written in verse and the key words underlined, is one of Bray's earliest attempts to test the Post Office.

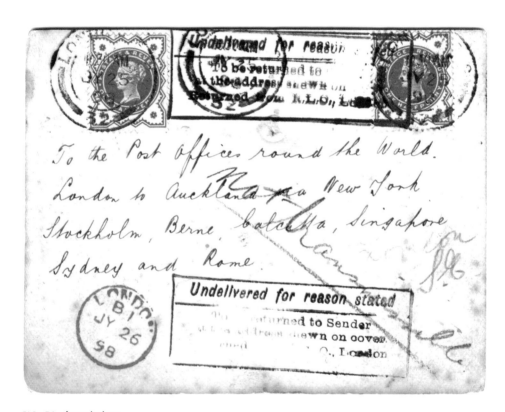

FIG. 30. An audacious
attempt to send a
postcard around the
world for a mere penny.

Delighted that the first card arrived safely, Bray promptly devised a series of new methods to challenge the authorities' claim that all post "must be delivered as addressed." He sent a large number of cards to nonspecific recipients at vague and oddly poetic locations; for example, in July 1898 he sent one "To the Post Offices round the World, London to Auckland via New York, Stockholm, Berne, Calcutta, Singapore, Sydney and Rome." » [FIG. 30] The message on the back instructed the Post Office to return the card to Stanstead Road once it had passed through all the countries mentioned on the front. It didn't get far: the Post Office decided that the card was incorrectly addressed and returned it to him the following day as undeliverable. Another such card was sent in early 1899, simply addressed to "Mr. W. R. Bray, London." » [FIG. 31] This one did not make it back to his letterbox at Stanstead Road, but it wasn't lost forever, as he made sure to include a return address, in this case, his friend Arnold's, at 361 Brockley Road, Crofton Park, where it safely arrived five days later. It is worth noting that Bray always included a return address, either his own or Arnold's. This way he ensured that, one way or another, he would be reunited with his creations.

At other times Bray took a different tack, including a specific location but an intentionally vague or impossible recipient. The earliest identified thus far is one sent on July 30, 1898, to "a Resident," Fingal's Cave, Staffa. Fingal's Cave is a sea cave located on the shore of the island of Staffa in the Outer Hebrides, Scotland. The cave is formed out of spectacular hexagon-shaped basalt columns. » [FIG. 32] Bray sent similar cards to "a Resident of Hallingbury, Essex, where, land used to be held by handing over yearly to the King's Exchequer a Pack of Postcards and a Silver Needle"; the keepers of three different lighthouses, through a round-robin card; "Any Resident of London"; and "the Proprietor of the most remarkable hotel in the world on the road between Santa Cruz and San José, California." » [FIG. 33–36]

Bray pushed his address experimentation a step further when he sent a card to a well-recognised but entirely fictitious recipient. In 1899 he addressed a postcard to "Santa Claus Esq.," intentionally

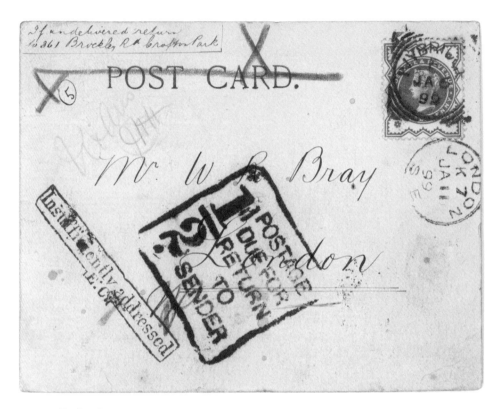

FIG. 31. The fact that
this postcard sent to "Mr.
W. R. Bray, London" bears
an Ivybridge postmark
suggests that Arnold,
Bray's co-conspirator,
posted it.

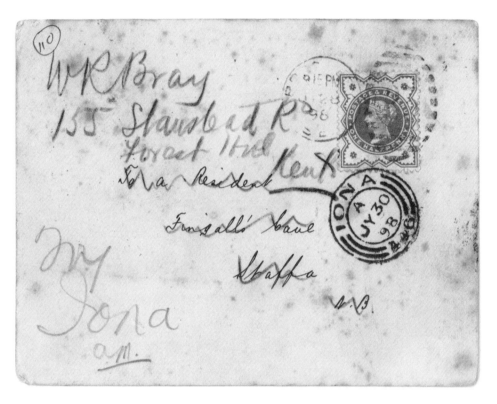

FIG. 32. This postcard
sent to "a Resident,
Fingall's [sic] Cave" was
impossible to deliver,
since Fingal's Cave is
uninhabited.

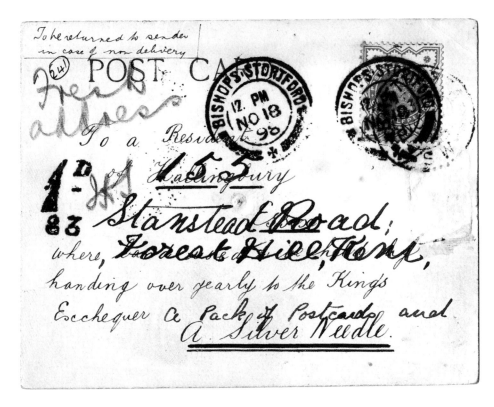

FIG. 33. A postcard sent to "a Resident of Hallingbury, Essex, where land used to be held by handing over yearly to the King's Exchequer a Pack of Postcards and a Silver Needle." The tradition of the silver needle dates back to the twelfth century. Not sure about the pack of postcards, but I suspect this statement was added by a cheeky postman.

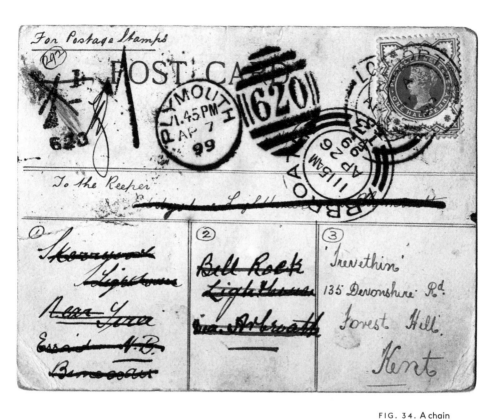

FIG. 34. A chain postcard made its way to Eddystone Lighthouse, Skerryvore Lighthouse, and, finally, Bell Rock Lighthouse, before the postman returned it to Forest Hill.

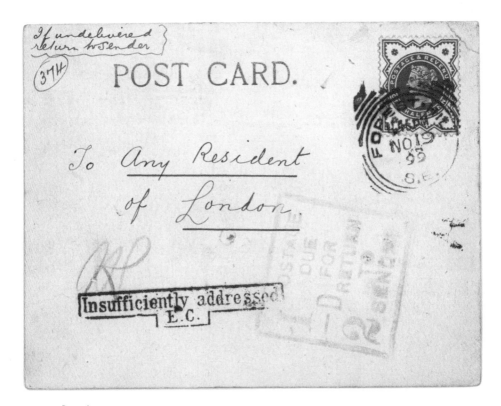

FIG. 35. Bray also tried sending a postcard to "Any Resident of London." Not amused, the Post Office returned it to Bray marked "insufficiently addressed."

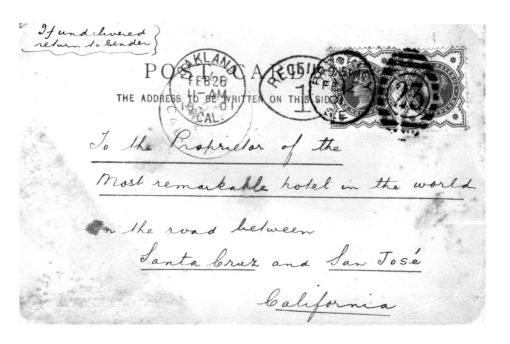

FIG. 36. When Bray sent a postcard to "the Proprietor of the Most remarkable hotel in the world on the road between Santa Cruz and San José, California," he was referring to the Hotel de Redwood, which was built in live redwood trees and stumps in the Santa Cruz Mountains in 1859.

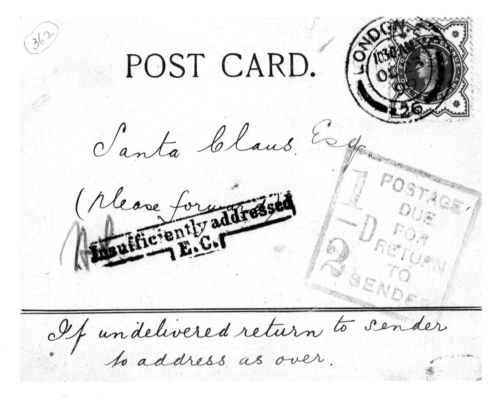

POST CARD.

Santa Claus Esq.

(Please forward

Insufficiently addressed
E.C.

POSTAGE DUE FOR RETURN TO SENDER

If undelivered return to sender
to address as over.

FIG. 37. Even posting
this card two months
before the Christmas
rush did not help Bray's
chances.

omitting an address since the British Post Office didn't officially accept cards addressed to Santa Claus at the North Pole until 1963, when authorities introduced a scheme to allow British children to receive a letter from Father Christmas. Letters posted to Santa Claus at fictional addresses such as Reindeerland, Snowland, or Toyland and including the name and address of the sender received a response from the Post Office free of charge. » [FIG. 37]

When he wasn't in the mood to conjure up his next recipient from his imagination, he turned to picture postcards for ideas. The picture postcard became popular in the late nineteenth and early twentieth centuries, as Edwardians began sending and collecting this form of ephemera, and Bray, ever on the lookout for creative ways to subvert postal rules, took advantage of this new visual opportunity. He started sending illustrated postcards to unnamed persons at the locations depicted on the cards, with an appropriate and specific instruction on the front, or picture side, such as "To the Occupier," "To a resident nearest," or, for lighthouses, "To the Keeper." » [FIG. 38–40] Modes of transport figured high on Bray's list of varied interests, which explains why he sent a number of such cards to train drivers, officials at railway stations, and ships' captains. » [FIGS. 41–44] In all cases, the card bore a request for some trivial piece of information to be supplied and then returned to him.

One such postcard, sent to the Brighton Fire Brigade, did not come back signed, as Bray requested, but it did uncover an interesting story. The photograph of the fire brigade appeared on a postcard purporting to illustrate the crew that attended the Great Lewes Fire of 1905. The card came back unsigned, along with a covering letter confessing that the picture was taken at the Police Sports Ground some time before the actual fire took place. Bray had exposed a fraud. » [FIGS. 45–47]

Bray also looked to railway tickets, promotional labels, newspapers, and magazines for ideas. In 1898 he saw an opportunity to take advantage of small, stamp-like publicity labels produced by

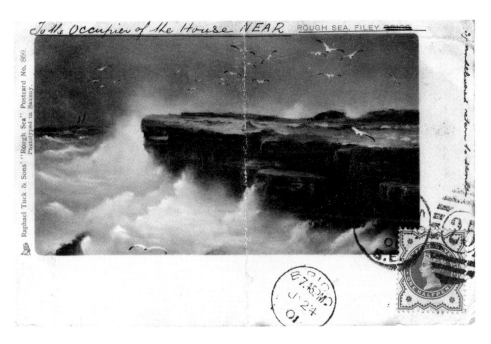

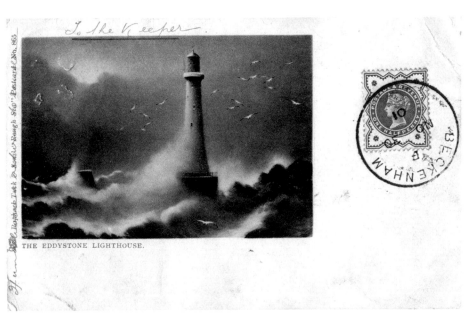

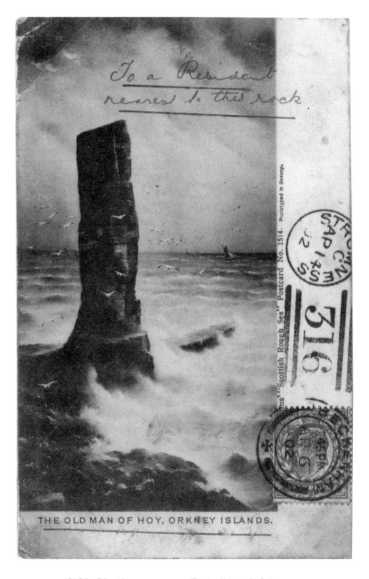

FIGS. 38–40. (OPPOSITE, TOP AND BOTTOM) Bray sent these postcards to "the Occupier of the house NEAR" (Filey); "To the Keeper" of the Eddystone Lighthouse; and (ABOVE) to "a Resident nearest to this rock" (Old Man of Hoy, Orkney Islands).

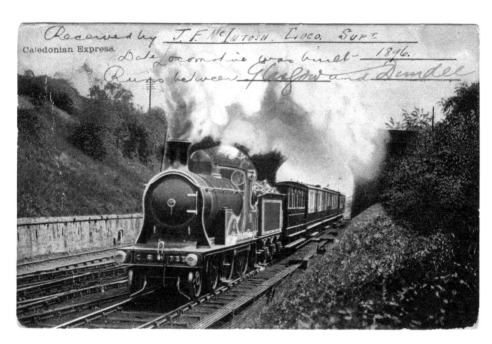

FIG. 41. "Driver of
Locomotive no. 733,
Caledonian Railway,
Glasgow Station"
received this postcard.

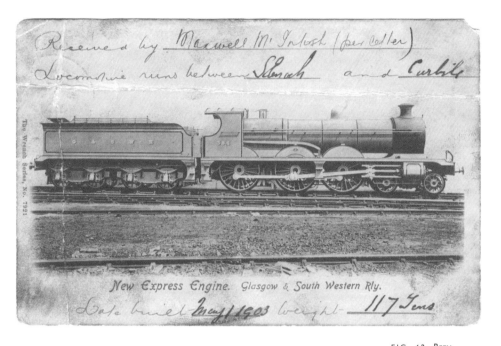

FIG. 42. Bray directed this picture postcard to the "Driver of Locomotive no. 384, Glasgow and South Western Railway, Glasgow."

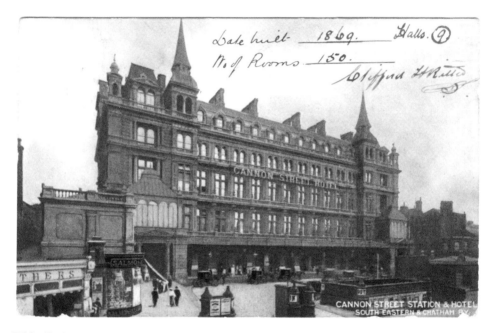

FIGS. 43–44.
Bray sent these
postcards to the
"Proprietor, Cannon
St. Hotel, Cannon
St. E.C." and to the
"Captain of the
Argentinean Training
Ship," *Presidente
Sarmiento*.

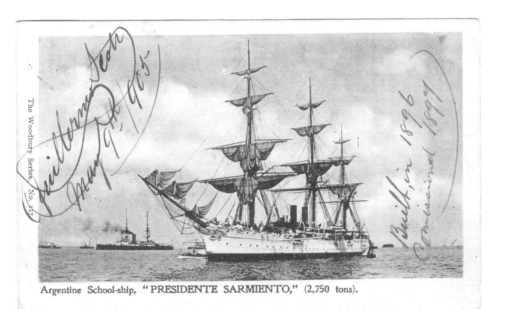

Argentine School-ship, "PRESIDENTE SARMIENTO," (2,750 tons).

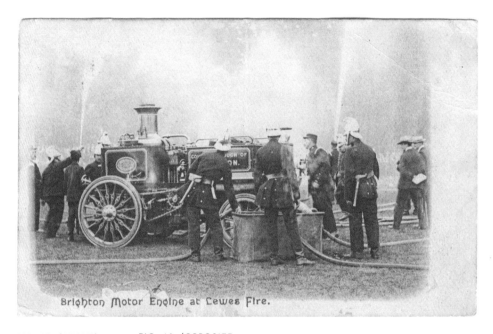

Brighton Motor Engine at Lewes Fire.

FIG. 45. (ABOVE)
Bray addressed this
picture postcard to "the
members of the Motor
Fire Engine Brigade,
Lewes," asking for some
trivial information to be
supplied.

FIG. 46. (OPPOSITE,
TOP) The crew featured
in the photograph had
nothing to do with
the Great Lewes Fire,
according to this letter
sent back to Bray with
the Lewes Fire Brigade
postcard.

FIG. 47. (OPPOSITE,
BOTTOM) This picture
postcard shows the Great
Lewes Fire in 1905.

Brighton Borough Police,
Fire Department.

Mch 24 1906

FROM

THE FIRE SUPERINTENDENT,
HEAD QUARTERS,
PRESTON CIRCUS.

W^to R. Bray Esq

Dear Sir,
I very much regret that your postcard of November 28th 1905 was not answered before, but I take this opportunity of writing to inform you that it is not the scene of the Lewes fire, but that it is a Photograph taken at the Police Sports sometime previous to the fire & I herewith return same.
Yours faithfully,
L. T. Lacroix.
Fire Superintendent

N.S. 2515—11/1905—500

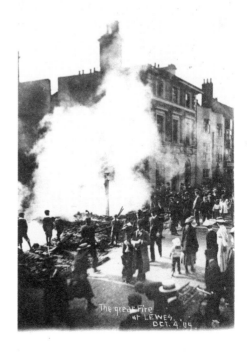

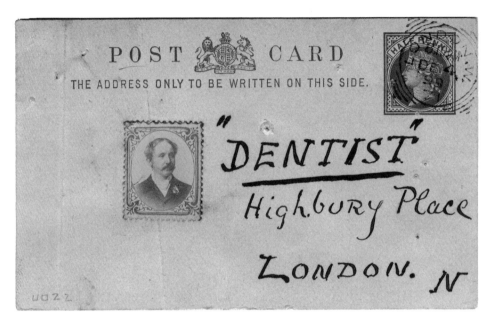

FIG. 48. Bray addressed this plain postcard to his cousin, G. Forster. In place of the recipient's name, he attached a small picture the size of a postage stamp and wrote the word "DENTIST."

his cousin, a dentist named G. Forster. » ⌈FIG. 48⌉ The following year Bray affixed a railway ticket to the front of a card, asking the Post Office to deliver it to the "Postmasters of" the departure and destination stations, with a message on the back requesting that the first Postmaster forward it to the second. » ⌈FIG. 49⌉

Periodicals provided Bray with more destinations to "visit." He scoured newspapers and magazines looking for small photographs of towns and villages around Britain. When he discovered a suitable image, he cut it out, stuck it to the front of a postcard with the handwritten words "To a resident," and posted it with a request that it be returned to him by the recipient:

> *Dear Sir (or Madam)*
> *Will you kindly redirect this post card to the above*
> *address as I want to test the skill of the postal au-*
> *thorities with regard to cards pictorially addressed.*
> *Thank you in anticipation.*

Bray despatched the first of these on October 2, 1899, addressed "To a resident of" (picture of Lynmouth Harbour) "Via Barnstaple." Either the postal carrier failed to identify the picture or decided that it was outside his remit to do so. » ⌈FIG. 50⌉ Bray sent another one later the same month, this one "To a Resident" (picture of Bournemouth Pier) "Hampshire." The Bournemouth postmark proves that the Post Office deciphered his puzzle but still charged him an extra penny for its return. » ⌈FIG. 51⌉

Occasionally Bray concocted cards that required more energy and ingenuity on the part of the Post Office to decipher the recipient's address. He sent one of these to the postmaster at the Quarter Sorting Office—Quarter being a village in Hamilton, South Lanarkshire, Scotland. Instead of writing the word Quarter, he used the fraction symbol, 1/4. » ⌈FIG. 52⌉ The Post Office failed this test and returned the card with an instructional mark advising the sender that it was insufficiently addressed.

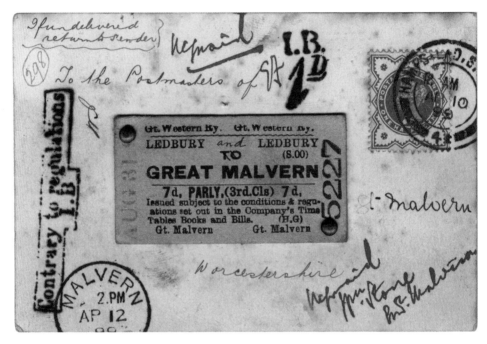

FIG. 49. (ABOVE)
In this case, Bray
attached a railway ticket
for the journey from
Ledbury to Malvern
instead of the address.
Above the ticket he wrote
"To the Postmasters of."
Bray altered the ticket to
indicate that he wanted
the postcard delivered
to both Malvern and
Ledbury.

FIG. 50. (OPPOSITE,
TOP) A picture is
attached instead of the
location, on this postcard
sent to "a Resident
of" (Lynmouth) "Via
Barnstaple."

FIG. 51. (OPPOSITE,
BOTTOM) This card
was sent to "a Resident
of" (Bournemouth)
"Hampshire." The
postman, apparently
more amused than

annoyed, added his
own rhyme on the front
before returning it:
"Pursuing this game we
hope there are not many,
However for your hobby
you will have to pay a
penny."

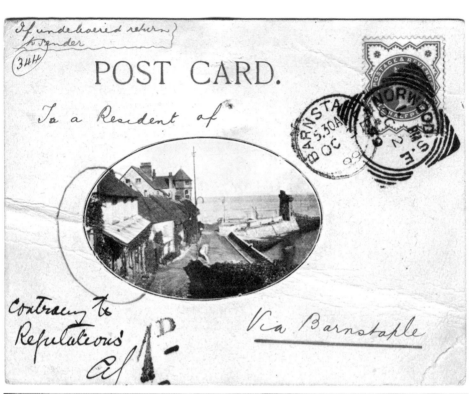

POST CARD.

If undelivered return to Sender

344

To a Resident of

Contrary to Reputations

Via Barnstaple

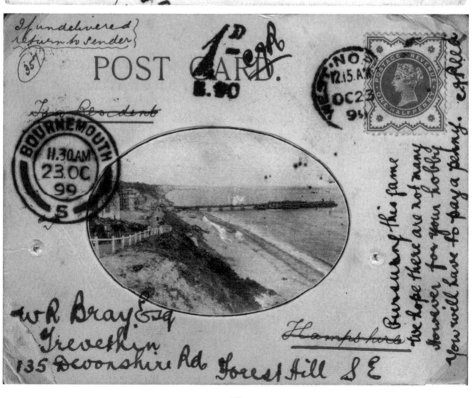

If undelivered return to sender

357

POST CARD.

1d

W R Bray Esq
Trevethin
135 Devonshire Rd Forest Hill S E

Hampshire

FIG. 52. For this postcard, sent to "the Postmaster ¼ S.O.," the intended recipient was the postmaster at the Sorting Office at Quarter in Hamilton, Scotland.

Using scissors and glue, Bray also collaged addresses from postmarks cut from previously posted items. In 1899 he sent one such cobbled together address to E. W. Arnold, 361 Brockley Road, Brockley, London S.E., and in 1900, he addressed another to Arnold, Brockley S.E. » ⌈FIGS. 53–54⌉ The Post Office rejected the former as contrary to regulations but delivered the latter successfully. In a way, these outcomes undermined Bray's larger mission, as he wanted to prove the flexibility of the regulations and the ingenuity of the postal carriers, not the inconsistencies of the delivery service.

Bray understood that these challenging addresses, although entertaining, caused a fair share of grief for the postal carriers. "How the sorters must have invoked the gods on my head when they caught site of my innocent postcards with the address written backwards," he wrote.[1] » ⌈FIG. 55⌉ Perhaps the most complex addresses to decode appeared in the form of small hand-drawn pictures. These cards showcase Bray's artistic talent and creativity. » ⌈FIGS. 56–57⌉

His most audacious endeavours didn't involve addresses constructed out of pictures or rhymes or photographs, but rather his measured response to the postal regulations concerning the delivery of "living letters":

> *Living animals can be accepted for express delivery, under this service, if confined in a suitable receptacle subject to the ordinary mileage fee. A dog furnished with a proper collar and chain may also be, at the discretion of the Postmaster, taken to its address on payment of the mileage charge, in addition to any charges that may have to be paid for the dog in respect of its carriage by public conveyance.*

Bray understood the practical advantages of this rule, and promoted the convenience of posting a dog:

1 *W. Reginald Bray, "Postal Curiosities," Royal Magazine, 1904, 140.*

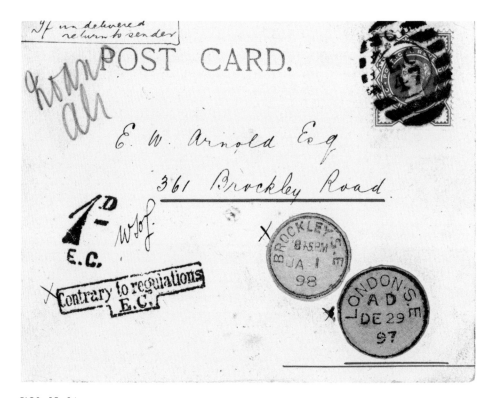

FIGS. 53–54.
Bray constructed these
addresses out of postmarks
cut out from old, previously
mailed, envelopes.

Now, should you one day take a stroll through the Park with a smart little terrier at your heels, and should you suddenly wish to send him home, what are you to do? The answer is simple. Why, take him to the nearest Post Office, of course! After handing in the address and paying a small fee, you may leave him and make your call. And when you return there you will find him waiting on the mat to greet you as lively as a cricket after his passage through the post.[2] » ⌈F I G . 5 8⌉

Fortunately for the Post Office, Bray did not count beekeeping among his many passions, otherwise we can be sure he would have put this rule to the test: "Live bees are allowed to pass by Letter or Parcel Post within the United Kingdom, on condition that they are sent in suitable cases, and so packed as to avoid all risk of injury to Officers of the Post Office or to other packets."

With his determination to push the boundaries as far as possible, he must have been delighted to read this particular regulation, outlined in plain language in the *Post Office Guide*: "a person may also be conducted by Express Messenger to any address on payment of the mileage charge." Mothers, he suspected, could particularly benefit from this service, as he explained in the same *Royal Magazine* article:

What mothers know that, if they like, they can send their little ones to school as letters? Possibly, as soon as the "mother-readers" see this, the Post Offices will be crowded with toddling infants, both in and out of "prams," all waiting to be taken to schools, or out for a day in the country. "But I should not like my child to be carried with postage stamps, and arrive at the school black with postmarks!" That is what I expect some mothers will say.

2 *Ibid.*, 141–2.

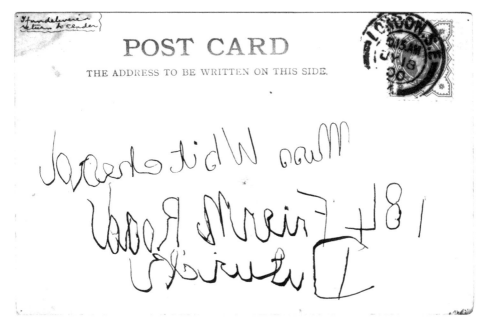

FIG. 55. Perhaps the
Post Office supplied their
workers with mirrors, since
this postcard was delivered
successfully, though written
backwards.

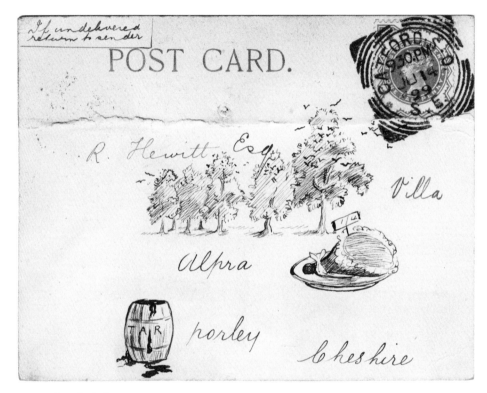

FIG. 56. From the lack of any instructional marks, it appears that the Post Office successfully deciphered this address, which reads, "Rookery Villa, Alpraham, Tarporley, Cheshire."

FIG. 57. The Post Office failed this test and declared the card "not addressed." The address reads, "361 Broccoli (Brockley) Road, Near LadyWell Wood, and LewisHam."

*Oh, don't be alarmed, nothing like this will
happen! All that you need to do is to take the child to
the Post Office across the road, pay a small fee, and a
messenger boy will escort the little one to the very door of
the school. However Post Office officials do not appear
anxious to gain fame as nurse providers to infants.*[3]

Naturally, he couldn't resist the temptation to test this regu-
lation himself. In 1931, Bray claimed to have been the first to send a
human through the post when he shipped himself on February 8, 1900,
and then again on November 14, 1903.[4] Whilst no proof of the first
delivery exists, when he repeated the exercise in 1903, he used the
Registered Mail service and obtained a certificate of registration, thus
providing historical evidence of his achievement. » [FIGS. 59-61] This
documentation challenges the British Postal Museum's previously
held belief that the first person to post himself in the British Isles was
Henry Turner of Guernsey. (Turner did indeed post himself, in 1905.)
In 1932, Bray posted himself a third and final time, reenacting the
scene as a publicity stunt. This time two postmen accompanied him
back to his home in Taymount Rise, Forest Hill, with a photographer
conveniently on hand to record the event for posterity. » [FIG. 62]

3 *Ibid., 141.*
4 *W. Reginald Bray, "Postal Freaks and Postal Facts,"* Post Annual, *1931, 35.*

DOGS AS LETTERS.

By W. REGINALD BRAY,

Owner of the Largest Collection of Postal Curios in the World.

IT may interest readers to know that should they wish to send their DOGS by post to a friend, it is quite possible to do so. (See " P.O. Guide," page 37, par. Exceptional Express Services.)

Reproduced below is the proof of posting my (late) Irish Terrier, Bob, on February 10, 1900, from Forest Hill Post Office, Kent, the journey taking exactly six minutes to accomplish, which in that year cost 3d. per mile, but which to-day costs 6d. per mile. —I claim to be the first person to have carried out this postal experiment, official proof of which can be obtained from the G.P.O., London, E.C.1. Certain animals when posted must be confined in a suitable receptacle, but dogs need not, so long as they are docile.

My dog was taken on an ordinary lead. Readers will ask what is the use of the Post Office extending such a service as this? I will tell you. Presuming you are sending your dog to a friend or veterinary surgeon and have not the time to take the animal yourself, this service comes immediately to your assistance.

To Miss Duffett
Feb 10th 1900.

"TREVETHIN,"
135, DEVONSHIRE ROAD,
FOREST HILL, KENT.

Herewith please receive Irish Terrier as a letter per Express Delivery which was despatched from Forest Hill post office at 6.54 pm by me the undersigned and which has now been delivered to your address as above.

A. J. A. Peters. Telegraph Messenger

Recd the above-mentioned animal

A. Duffett

Date Feb 10. 1900 Time 7.0

FIG. 58. In a 1932 newspaper article from Bray's scrapbook, he describes how he posted his dog.

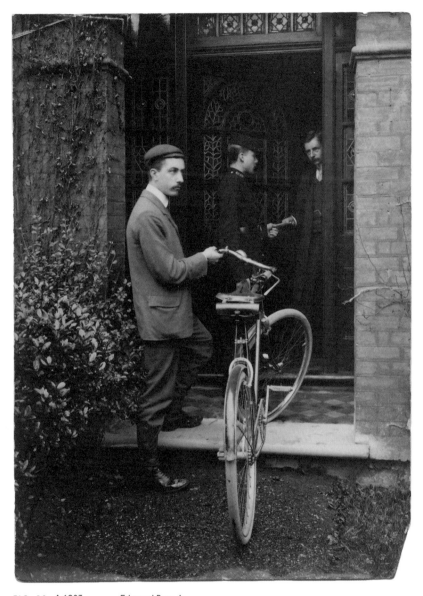

FIG. 59. A 1903
photograph shows
Bray being delivered
by registered post
to his home on
Devonshire Road.
His patient father,
Edmund Bray, is
standing in the
doorway, accepting
the receipt from the
postman.

Postmasters No. 87.

Acknowledgment of Delivery of an INLAND

REGISTERED *Person Cyclist*
[Insert Letter or Parcel.]

addressed to

(¹) *135 Devonshire Rd*

Forest Hill

S.E.

I acknowledge that the registered article mentioned
above and sent by

(²) *To Reginald Bray,*

135 Devonshire Rd

Forest Hill

was duly delivered on the *14 Nov 1903*

E.H. Bray

(Signature of Recipient.)

I certify that the registered article mentioned above
was duly delivered the *14th Nov. 1903*

(³) *WM Adams for.*

(Signature of Postmaster of Delivering Office.)

The names and full addresses of the sender and addressee should be carefully inserted
by the sender, or at the issuing office, in spaces (1) and (2).

If the recipient objects to complete and sign the acknowledgment (2), then the
certificate (3) must be completed and signed by the Postmaster of the delivering office.

**Stamp of Office
of Origin.**

**Stamp of
Delivering Office.**

**Stamp of
Delivering Office.**

FIG. 60 This Post Office
form acknowledges that
Bray had been safely
delivered by registered post.

Mr. Reginald Bray - 'Postal Freaks' -

Interviewer: What made you start your uncommon hobby Mr. Bray?

Mr. Bray: In 1898 I made a complete study of the Postal Guide and decided to give the G.P.O. a severe test without infringing its regulations.

Interviewer: What was your first experiment? Mr Bray.

Mr. Bray: I commenced by sending freak letters. For instance, I actually wrote addresses and messages on such articles as bowler hats, pipes, cycle pumps, frying pans, hand bags, dog biscuits, boots, collars, cuffs, braces, cigarettes, and even on turnips and a rabbit's skull, and posted them as ordinary letters without a covering or tie-on label. It is not easy writing on a turnip, so I carved the address with a pen knife, and it was delivered intact, as were all my freak letters, even a lady's hand bag which was closed and posted with the address and stamps inside. These tests were carried out many years ago. Most of them would be accepted today, but rabbit skulls and turnips posted in a letter box without a wrapping would be officially treated as 'embarrassing' and with-held from delivery.

Interviewer: Yes, I suppose they would. Have you made any other test?

Mr. Bray: In 1900 I posted myself, and was the first human letter. Later Post Office Officials were good enough to accept and deliver me and my bicycle as a letter.

Interviewer: Good gracious. Could you do that now?

Mr. Bray: Yes certainly, by the Express Delivery Service - A messenger is sent with the human letter and frankly it's a very useful service. Once on a very foggy night I could not find a friend's house so instead of wandering about for hours I posted myself and was delivered in a few minutes.

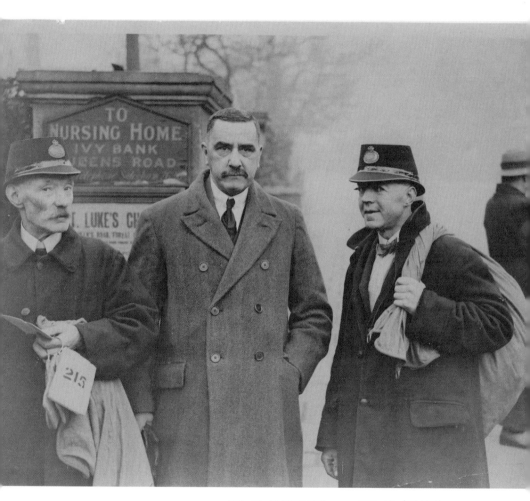

FIG. 61. (OPPOSITE)
A page of script from the
BBC radio programme
In Town Tonight, which
featured Bray in 1935
and 1936. In this interview
he describes the merits of
posting oneself.

FIG. 62. (ABOVE)
This photograph shows
Bray being delivered by
two postmen in 1932.

Postmarks–Where in the World?

As he learned more about the rules and regulations of the Post Office, Bray became fascinated by the number and variety of postmarks used in Great Britain. A postmark is defined as a handwritten, hand-stamped, or machine-made mark applied to an item that has passed through the post. These include cancellations, which is a more specific term for the postmark used to cancel the postage stamp in order to prevent its illegal reuse.

In the 1934 edition of the *Post Annual,* a publication that featured well-informed articles about the postal service, Bray wrote about the history of British postmarks.[1] In the article he revealed a keen understanding of the evolution of British postmarks by displaying an in-depth knowledge of the various types of marks that were used from the mid-seventeenth century right up to the 1930s.

He collected postmarks and sent a number of creations into the world for the sole purpose of adding new postmarks to his growing archive. Whilst visiting Eastbourne in June 1897, he sent himself a postcard with the following message:

> *Dear Bray*
> *I have just walked to Beachy Head & back and am now going to*
> *Eastbourne Town. Shall come home by 7 5pm —Norwood June*
> *& then to Forest Hill.*
> *From Reginald*

This message is clearly self-addressed. Why would he write such a card unless he just wanted to add an Eastbourne cancellation to his collection? This would also explain why he still possessed the card more than a year later. In November 1898 he decided to see what would happen if he reposted the card, this time to a fictitious address. » [FIG. 63] The fact that it bears an Ivybridge postmark implies that Arnold may have been involved, since he was there earlier that year. It is a good bet that Bray was testing the regulation stating that mail was not liable to additional postage for redirection, as long as

1 *W. Reginald Bray, "Postmarks,"* Post Annual, *1934.*

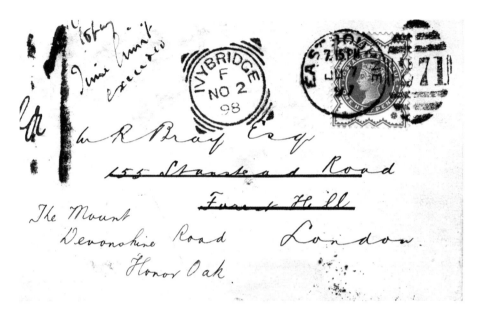

FIG. 63. When Bray redirected a previously used postcard more than a year later, the Post Office took the view that seventeen months far exceeded the maximum one day permitted and duly imposed a penny surcharge.

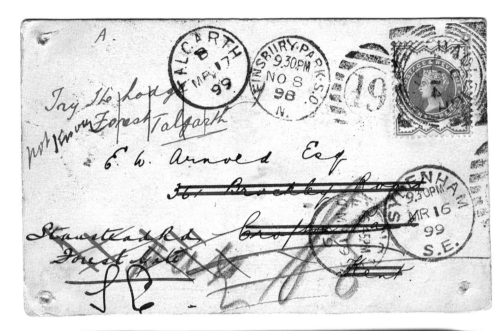

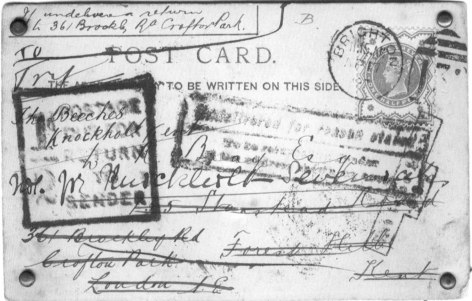

FIGS. 64–65. Examples
of two previously used
postcards that Bray
joined back-to-back and
constantly reposted.

it is reposted no later than the day after delivery and has not been tampered with.

Adding another layer of complexity, in 1898 Bray tried joining two previously posted cards back-to-back. He had originally sent one of these to Arnold whilst staying at Shelly Hall in 1897. The other he had sent to his family when he visited Brighton, also in 1897. He crossed out both of the original addresses and redirected this double card to Stanstead Road, Forest Gate—a fictitious address. He took the precaution of writing his usual request to return undelivered mail, in this case to Arnold's home on Brockley Road, and the card inevitably came back bearing a variety of postal markings. Not content with this, Bray readdressed the card again, this time to The Beeches, Knockholt, Kent. This address was also contrived so, as before, the card came back. Still not satisfied, he added another address, The Lodge, Forest, Talgarth, a third wild-goose chase for this overworked card. By the time it finished its journey, the double card had collected a variety of postmarks between April 1897 and March 1899. » ⌈FIGS. 64–65⌉

In December 1898 Bray sent a sealed envelope with an old, previously used 1864 penny stamp to "George Freeport Esq, Dove Holes, Near Buxton." The address was, of course, rubbish. This time Bray used an envelope instead of his usual postcard. Naturally, the Post Office returned the item to him four days after he sent it, this time bearing a surcharge of two pence (twice the cost of the unpaid postage, since the postage stamp was invalid).[2] The cover managed to collect a nice Buxton postmark, one from New Cross Sorting Office, and a 2d. charge mark. » ⌈FIG. 66⌉

The incorrigible rogue was at it again a few weeks later, when he sent a card to Arnold in late December 1898 asking him to redirect it to "Stanstead Villa, Forest Saw Mills, Yorks," another fictitious address, with the hope that it would arrive back in Forest Hill about January 4, 1899. He signed this card "Dick Mizzle."[3] » ⌈FIGS. 67–68⌉

2 *It cost a halfpenny to send a postcard and one penny to send a letter.*
3 *"Dick Mizzle" was a fictional character featured in the play* Borrowed Plumes *that ran at the Adelphi Theatre in London, in 1885. Bray used this name to conceal the fact that he wanted the card sent to himself.*

FIG. 66. Addressed to
a fictitious person, this
envelope bears a postage
stamp used on another
letter some twenty years
previously. Faced with
this double test—the
unknown address and
the old stamp—the Post
Office passed with flying
colours.

FIG. 67. Arnold redirected this postcard to a fake address, as requested by Bray in his message on the back.

FIG. 68. (ABOVE)
Here is the back of the
postcard, with Bray's
message to Arnold
asking him to forward
it to a nonexistent
address.

FIG. 69. (OPPOSITE)
Arnold originally sent
this postcard to his
mother in April 1898.
Bray commandeered it,
redirecting the card to
himself at Broadmoor
(a lunatic asylum) in
February 1899.

Bray involved Arnold again when he acquired a card that Arnold originally sent to his mother confirming his safe arrival in Brighton in April 1898. Bray crossed out the original name and address and wrote, "c/o W. R. Bray Esq, The Village, Broadmoor" on the front and dropped it back into the post. Perhaps Bray doubted his own sanity—at that time Broadmoor was classified as an asylum for the criminally insane. » [FIG. 69]

Bray's interests in train travel and postal experiments joined forces when, in January 1899, he hit on a new idea to boost his postmark collection. He started leaving cards on railway carriages to be found and, he hoped, returned from some far-off town. To catch the finder's attention he wrote the following message on the cards:

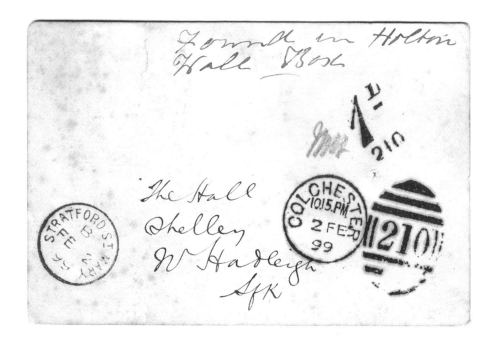

Will the one who picks this P card up
At once without delay
Direct it to th' above address
Where resides W. R. Bray

At least three of these succeeded. Walter Merchant found the first on a Great Eastern Railway train at Lexden, near Colchester. George Williams found the second at Stratford Carriage Sidings and posted it back in late January 1899, although in Bray's typically mischievous style, the return address was slightly fictitious. He had asked for it to be sent to him at "Stanstead Road, Forest, Talgarth." Talgarth is in Wales! A Mrs. Furman found the third at Holton St. Mary, Suffolk, on February 2, 1899, and returned it to Bray at "The Hall, Shelley." Bray failed to put a postage stamp on the card, and Mrs. Furman was unwilling to pay for it, so the card arrived back complete with a 1d. postage due charge mark. » ⌈FIGS. 70–71⌉

FIG. 70. (OPPOSITE)
One of the cards Bray left
on a train to be found and
sent back to him.

FIG. 71. (ABOVE)
The message on the
back, written in verse,
asked the finder to write
his/her name, location, and
date of discovery before
returning it.

Following the success of these cards, Bray branched out quite a bit, varying his methods. He started attaching cards to a copy of a popular periodical of the day, *Tit-Bits*, a weekly magazine that specialised in sensational human-interest stories. This time Bray wrote: "Will the person who picks this copy of Tit Bits [*sic*] up kindly send this card to the address below and fill up the other side."

Annie Weaver returned one such card from a village near Riverhead in Kent in June 1899. William Rendle sent back another from Ermington in Devon in August of the same year. The second card was sent back in an envelope posted in Ivybridge, which was a favourite summer destination of Arnold's, who was fond of a woman who lived there. » [FIG. 72] Possibly Arnold had been enlisted, yet again, as Bray's accomplice.

In 1899 Bray became a bit more ambitious and sent a postcard addressed to himself at "Imam Muscat House, Zanzibar, East Africa," with a half anna Zanzibar stamp affixed instead of a British stamp. Apart from the fact that he hadn't used a valid stamp, it is no surprise it never made it, since the sender was safely ensconced in his house in Forest Hill. » [FIG. 73]

Inspired by his success with *Tit-Bits*, Bray developed a more sophisticated technique that was, in my opinion, his most bizarre and inventive. This method is best explained in his own words:

> *I made most of my friends believe I had travelled all over the world. First of all I wrote my letter, say from Japan, then procured the proper postage stamps required for postage from Japan to London. After this was completed I obtained a bulky newspaper, which I directed to a fictitious address in Japan and placed my letter tightly in the folds of it; then I posted my newspaper in the ordinary way and all was done. The newspaper, on arrival at the Dead Letter Office, was sorted for destruction, when my letter would fall out*

Will the person who
picks this copy of Tit Bits
up kindly send this
card to the address
below and fill up
the other side.
W R Bray
Trevethin
135 Devonshire Rd
Forest Hill C.S.1

3.6.99.

FIG. 72. A card Bray
attached to a copy of the
magazine *Tit-Bits* and left on
a train to be discovered and
sent back to him.

FIG. 73. Bray sent this envelope to himself at a fictitious address in Zanzibar. Even though the correct postage had not been paid, it still travelled all the way to Zanzibar before finally arriving back in London more than three months later on October 18, 1899. Nicely done!

FIG. 74. Bray hid this postcard in a newspaper sent to Bulawayo. The ½d. postage stamp at the bottom left presumably covered the postage cost of sending the newspaper to Rhodesia, hence the NPB (Newspaper Branch) cancellation.

Dear Sir

Will you kindly send
by next mail the
magazine Xmas
numbers as many
copies as possible
as there are some I
wish to forward on
by first messenger
from here, please
send catalogue of
monograms from
your Stationers I oblige
Yours truly
J. Saming
£3

FIG. 75. The back of
the card that Bray hid
inside the newspaper
and sent to Rhodesia.
He wrote a spoof
message to make it
appear legitimate.

*quite readily for despatch to London properly stamped, and
eventually arrive in the ordinary way.*[4]

These cards travelled back to him from all over the world,
which amazed his friends until he explained his technique. Since these
cards have no special markings or other curious features, they are
hard to recognise. In fact, the only one I have encountered to date
is one sent back from Rhodesia in January 1900. To conceal the fact
that he sent the card to himself, he wrote a spoof message on the back
purporting to be someone else, in this case, "J. Saming." » [FIGS. 74–75]
We have already seen this device used on other cards and curios.

Realising that the water's currents could assist him in his
efforts, in September 1900 Bray placed a message in a tobacco tin and
asked a friend to throw it into a river or the ocean on a visit to Wales.
The tin washed up on a beach near Holyhead and was returned by
William Jones.

The following year Bray sealed a message inside a bottle,
which he threw into the sea one and a half miles off the coast near
Southend-on-Sea, Essex. The message inside read:

*A postal order of 1/- will be forwarded to the person who
returns this paper filled up as below and who also fills up
the particulars as requested on the enclosed postcard. The
postcard must be stamped and posted at the nearest pillar box
to where the bottle was found, but this should be sent under
cover. If bottle is returned (with cork) unbroken 1/6 will be
forwarded instead of 1/=.*[5]

How disappointed he must have been when it washed up a short
distance away on the shore of Foulness Island. » [FIGS. 76–78]

In 1906 Bray coerced a friend to drop a bottle over the side of
a ferry travelling between Folkestone and Dunkirk. Inside the bottle
Bray slipped a card addressed to J. G. Hargreaves, the father of Bray's

4 *W. Reginald Bray, "Postal Freaks and Postal Facts,"* Post Annual, *1931, 36.*
5 *Both 1/- and 1/= equal one shilling; 1/6 equals one shilling and sixpence.*

FIG. 76–78. Bray tucked
this card (ABOVE), set of
instructions (OPPOSITE),
and letter (OVERLEAF)
inside a bottle and cast it
into the sea at Southend.
The bottle washed up
on the shore a few miles
away and was returned to
him on October 16, 1901.

A postal order for 1/ will be forwarded to the person who returns this paper filled up as below/ and who also fills up the particulars as requested on the enclosed postcards.

The postcard must be stamped and posted at the nearest pillar box to where the bottle was found, but this should be sent under cover. (If bottle is returned (with cork) unbroken 1/6 will be forwarded instead of 1/=)

Found by. ___ W. Fitch

Address in full. ___ East Wick Fowlness Island Essex

Found at East Wick Head Way Maplin Sand as Tide Was

Full particulars coming in Leaning Shore N West from Mouse Light Ship & 5 miles North of ___

Date 14 -11- 1901 Time 3-30- P.M.

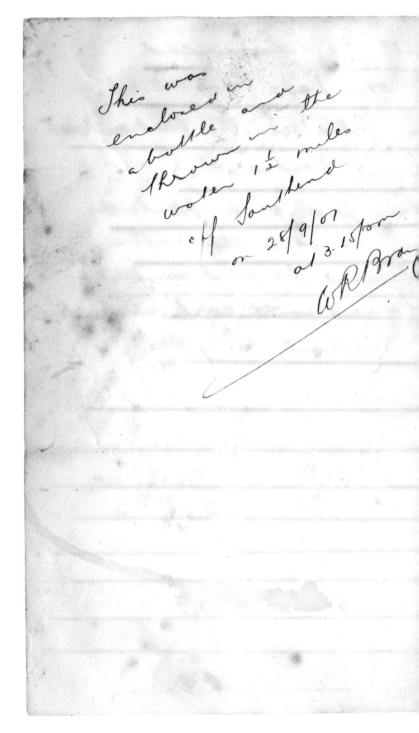

This was
enclosed in
a bottle and
thrown in the
water 1½ miles
off Southend
on 28/9/07
at 3.15pm

WRBra

Trebethin,
135, Devonshire Road,
Forest Hill, S.E.

England

September 1901.

To the Finder

Kindly fill in the
particulars inside and
return to the above
address without delay.

Despatched
by W R Bray

W. R. BRAY,
135, DEVONSHIRE ROAD,
FOREST HILL, S.E.

30.77.

This card was consigned to the sea between Folkestone & Dunkirk on August 22:1906 by W Reginald Bray

Found by Max Madsen at Hjergaard pr Oxbol Danmark N.B. 55°42'0&28°12'

Date 1 Desember Time 1906

IF UNDELIVERED RETURN TO SENDER.

Per Daily Graphic Balloon

POST CARD

Card No. 8973

FOR INLAND USE ONLY.
PRINTED OR WRITTEN MATTER.

ONLY THE ADDRESS TO BE WRITTEN HERE.

Despatched By Mr. A. V. Michow Mellerud

Date 20/12 Time 6 p.m.

Found by Mr. Andersson At near Mellerud, Sweden

Date ? Time ?

J. G. Hargreaves Esq.
"Fairview"
Ewelme Rd
Forest Hill
England London

FIG. 79. (TOP)
This postcard was placed inside a bottle and tossed into the sea between Folkestone and Dunkirk.

FIG. 80. (ABOVE)
Released from the *Daily Graphic*'s hot air balloon, this postcard was found in Sweden and returned to Mr. Hargreaves.

fiancée, Mabel Louise Hargreaves. The bottle managed to travel all the way to Oxbol (Oksbøl), Denmark, a small town in the region of Sønderjylland before it was returned to Bray's future father-in-law. Not bad. » [FIG. 79] Mr. Hargreaves was the lucky recipient of two more bottle messages. One arrived in September 1907, after it washed up in Dorset, having been consigned to the waves between St. Malo, France, and Southampton. The other was thrown into the sea by a friend who was travelling on a ship between Liverpool and Toronto and finally washed up in the Shetland Isles. Bray placed two postcards in this final bottle; the second one addressed to himself. Mabel's sister Nellie was also the target of a bottle message. Bray launched hers in July 1907 between London and Yarmouth. It managed to travel all the way to Germany!

Eager to use the wind as he had used the waves, Bray persuaded hot air balloonists to release cards attached to smaller gas-filled balloons high up in the sky. I know of one such card, released from the *Daily Graphic*'s hot air balloon, Mammoth, in September 1907. » [FIG. 80]

Bray was relentlessly inventive in dreaming up ways to collect postmarks from places he would never visit. His ploys involved rail, sea, and air transport (not to mention friends and family) to disperse his postal creations far and wide. Some methods were more successful than others. It appears one of the least dramatic techniques—hiding a card in the folds of a rolled-up newspaper and dropping it in the mail to a country thousands of miles away—brought terrific results, with postmarks from another continent showing up in his letter box in Forest Hill.

The Autograph King

When Bray wasn't coordinating a bottle launch or a hot air balloon release, he sought autographs through the post. In 1906 he claimed to own the largest collection of modern autographs in the world and anointed himself "The Autograph King." This title graced stacks of personalised preprinted autograph-request postcards, commissioned by Bray and sent out into the world. » ⌈FIG. 81⌉ In an unusual strategy, he amassed his collection entirely through the post, without ever approaching a target in person.

His quest for autographs most likely began with a note he sent to President Kruger in October 1899. » ⌈FIGS. 82-83⌉ The Second Boer War had broken out four days earlier, and Bray audaciously sent a card to the leader of the enemy nation.[1] The message on the back merely asked for it to be returned. Bray almost certainly had no expectations that the card would get through. He was just curious to see what would happen and how many interesting postmarks the piece would collect on its round-trip journey to South Africa. It came back festooned with a wonderful array of cachets and marks, including a highly sought after "mail service suspended." Encouraged by this success, Bray devised techniques to collect the signatures of as many participants of the Boer War as possible.

> *During the Boer War I sent postcards to almost every General at the Front, without once writing their names. British Field Forces, South Africa, was all the address I gave, with a miniature photograph of the particular General whom I wished to communicate with attached to the card.*[2]

The miniature photographs were, in fact, cigarette cards: small picture cards included as free giveaways inside cigarette packs. Printed in sets, the cards attracted a loyal following of smokers determined to collect them all. A number of different brands of cigarettes were

1 *The Second Boer War (1899–1902), commonly referred to as the Boer War, was fought in South Africa between the Boers and the British.*
2 *W. Reginald Bray, "Postal Curiosities," Royal Magazine, 1904, 138.*

FROM

TELEPHONE: FOREST HILL 5270.

W. REGINALD BRAY, THE AUTOGRAPH KING.

The owner of the largest collection of Modern Autographs.

EXHIBITOR AT—

Naval and Military Exhibition, Crystal Palace, 1901.
do.　　　　　　Manchester and Leeds, 1903.
do.　　　　　　Earl's Court, 1905.
International Sports and Games Exhibition, Crystal Palace, 1904 *(Diploma Awarded)*.
Anglo-American Exhibition, Shepherd's Bush, 1914.

Claim to above title was broadcast personally from Broadcasting House, LONDON, on 31st October, 1936.

Please quote Register No. 28800/969
if Photo is used. 29096 .

8, QUEEN'S GARTH,
TAYMOUNT RISE,
FOREST HILL, S.E. 23,
ENGLAND.

23 December 1937

Kindly add your autograph on the other side (or on a photo)
and post same to me, thanking you in anticipation.

FIG. 81. The reverse side of one of Bray's preprinted postcards bears his claim to the title of "The Autograph King." This particular card demonstrates the complexity of Bray's register, when he needed to cross-reference certain entries.

15/10/99

"Trevethin"
135 Devonshire Road
Forest Hill
Kent
England.

Houses of Parliament

The Sender desires this card to
be re-directed back to the above
address for his large collection
of postcards etc etc —
 Thanking the person who
carries out his desire,
 Yours faithfully
 W. R. Bray

FIG. 82. (ABOVE) Bray sent this postcard to Transvaal's President Kruger. It did make it to South Africa but failed to reach its destination due to the suspension of mail services between the warring countries.

FIG. 83. (OPPOSITE) The reverse side of the postcard sent to President Kruger. Although Bray did not ask for an autograph here, he followed this card with many others seeking autographs of key participants in the Second Boer War.

available in the early twentieth century, but Ogden's Guinea Gold was one of the most popular. Bray cut off the name of the person featured on the cigarette card before attaching the image with paper fasteners to the front of his own postcard. Sometimes, when in a more helpful mood, he obtained a picture postcard featuring the officer and sent that to be autographed, in which case the British and South African postal authorities did not to have to work as hard to identify the intended recipient. The address, however, as Bray himself noted, typically provided little more information than "British Field Forces, South Africa." These days, many of the Boer War cards are coveted by postal historians and autograph collectors and do not come to market very often. When they do, they command very high prices. » ⌈FIGS. 84–88⌉

Bray designated a share of his Boer War cards for nonmilitary personalities. He targeted both Lady Sarah Wilson and Julian Ralph, celebrated war correspondents. » ⌈FIGS. 89–90⌉ He tried to secure the autograph of Winston Churchill, but Churchill charged one shilling's worth of stamps for the Church Army in response to such requests. » ⌈FIG. 91⌉ Determined to expand his collection, Bray turned his attention to celebrities a little closer to home. In 1901 he sent requests to a variety of famous personalities, including Edward Saunderson, an Irish politician; Alfred Austin, the Poet Laureate; and W. G. Grace, a famous cricketer. » ⌈FIG. 92⌉ Not all were successful. The artist George Frederick Watts, annoyed at being approached, mutilated the envelope before returning it with a curt message. » ⌈FIG. 93–94⌉ Autograph collecting was a popular hobby at the time, and many celebrities were unwilling to accede to the large number of daily queries. Bray took time to craft these eye-catching requests to set them apart from all the others. His handiwork often paid off.

With so many cards coming and going, the Post Office became increasingly aware of his output and sought to curb some of his activities. In a *Royal Magazine* article published in 1911, Bray described how he adapted to the new rules:

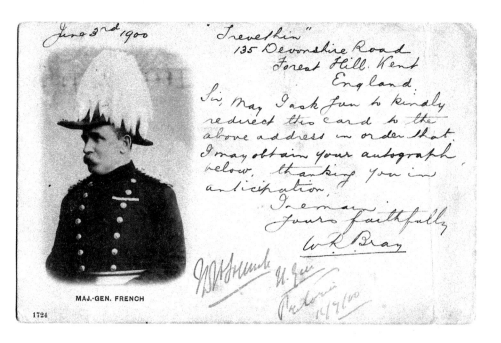

FIG. 84. Major-General French signed this postcard, the earliest recorded autograph collected by Bray.

LETTER CARD

Maj.-Gen. Hon. Neville Lyttelton, C.B.

Ogden's *Guinea Gold* Cigarettes.

POST
ONE PENNY

South Africa

Lyttelton

"Trevethin"
Devonshire Road
Forest Hill Kent
England.

July 1st 1900

Dear Sir,

Pardon me sending you this card addressed by photo but I am making a large postal collection, and want to know if you receive this. — Will you kindly return the whole letter card just as you receive it and add your autograph below — thanking you in anticipation

Yours faithfully
WR Bray

M Lyttelton
Lieut General

To Maj-Gen Hon. Neville Lyttelton.
Commanding Field Forces
4th Brigade Division

FIGS. 85–86. Both sides of a lettercard sent to Major General Lyttelton. Bray used an image of Lyttelton from a cigarette card and attached it to the front by paper fasteners, adding the address "South" (picture) "Africa." The general provided the required signature but kept his cigarette card. Bray subsequently attached Lyttelton's name to the letter once it arrived back in Forest Hill.

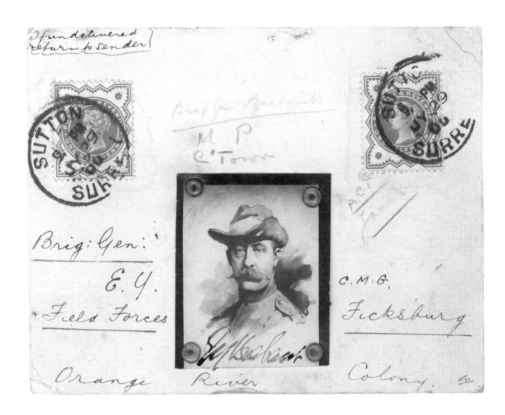

FIG. 87. This plain
postcard has a cigarette
card of Brigadier General
Edward Yewd Brabant
attached to the front by
paper fasteners. The card
was simply addressed
"Brigadier General E. Y.
Field Forces" (picture)
"CMG, Ficksburg, Orange
River Colony."

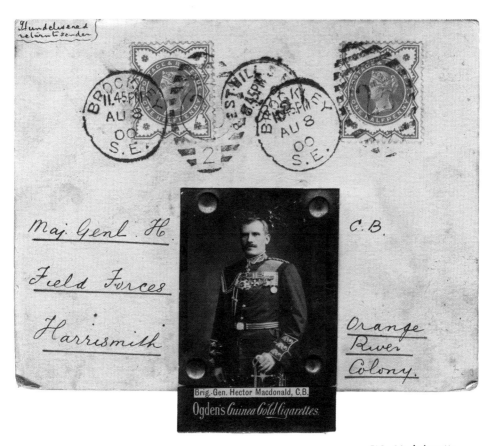

Handelivered
return to sender

Maj. Genl. H. C.B.

Field Forces

Harrismith Orange
 River
 Colony.

Brig.-Gen. Hector Macdonald, C.B.

Ogden's Guinea Gold Cigarettes.

FIG. 88. A cigarette
card of Brigadier General
Hector Macdonald is
attached to the front
of this plain postcard.
Once the postcard had
arrived back safely, Bray
reattached the brigadier
general's name.

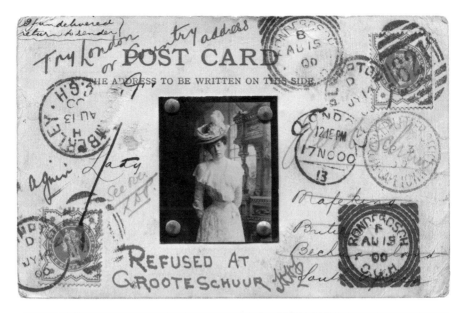

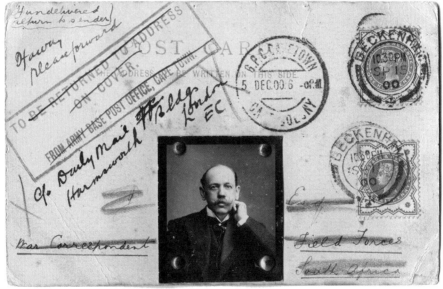

FIG. 89. (TOP)
A cigarette card
of the war correspon-
dent Lady Sarah
Wilson is attached
to the front of this
plain postcard. Lady
Wilson was the aunt of
Winston Churchill.

FIG. 90. (ABOVE)
Another plain postcard
with a cigarette
card attached, this
one depicting the
war correspondent
Julian Ralph. The card
travelled all the way
to South Africa before

it was redirected to
the offices of the *Daily
Mail* in London, where,
miraculously, Julian
Ralph signed the back
and returned it to Bray.

12, BOLTON STREET,
W.

May 16. 1900?

DEAR *Sir* ,

Mr. Churchill desires me to inform you that in order to do good to others and to save trouble to himself, he makes it a rule only to give an autograph when a sum of not less than 1/- is subscribed to the funds of the Church Army. If twelve stamps be enclosed in the letter requesting an autograph, together with a stamped and addressed envelope for reply, Mr. Churchill will be very glad to forward the donation to the Secretary of the Church Army, who will, in due course, send a receipt to the donor.

Yours faithfully,

A. ANNING.

Mr W. Reginald Bray.

FIG. 91. A letter from the offices of Winston Churchill explains that Bray would need to send one shilling's worth of unused postage stamps in order to obtain Churchill's autograph.

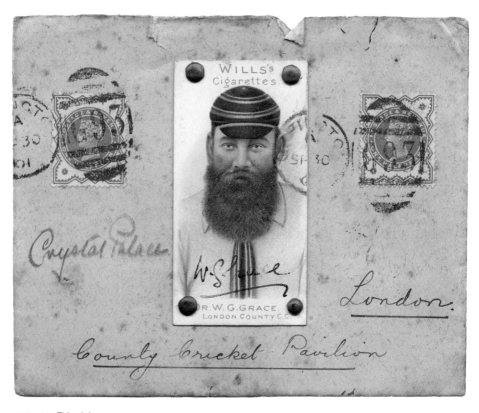

FIG. 92. This plain
postcard shows a
cigarette card of the
famous cricketer W. G.
Grace attached to the
front. For the first time,
Bray left the name of
the recipient intact.

FIGS. 93–94. (ABOVE
AND OVERLEAF)
The remains of an
envelope with a cigarette
card of George Frederick
Watts, artist, attached to
the front. A rejection note
was sent back with the
envelope.

LITTLE HOLLAND HOUSE,

KENSINGTON, W.

Mr. G. F. Watts regrets to say

that it is against a principle he holds,

with reference to the modern custom

of Autograph collecting, to accede to

the request just made to him.

*The time came when the Post Office banned not only
the paper-fastener method of attaching the picture, but
every form of appendage to the postcard. I was therefore
forced to seek a substitute. For a while I found this in the
ordinary letter-card to which a portrait could be fixed
without any breach of the regulations.*[3]

Now restricted from attaching cigarette cards and other small
pictures to the front of postcards, Bray, undeterred, relied exclusively
on lettercards instead, a format he had already used with some success
with the request he sent to General Lyttelton. » ⌈FIGS. 95-99⌉ First
pioneered in Belgium in 1882, lettercards were introduced by the Post
Office in 1892. This form of postal stationery consists of two cards
folded over and sealed by perforated edges that can be opened by the
recipient. Bray sent lettercards between 1900 and 1904, and continued
to post autograph requests on the backs of picture postcards.

The popularity of the theatre at the time meant that Bray
could choose from any number of theatre-related picture postcards to
send out as autograph requests. » ⌈FIGS. 100-102⌉ Occasionally he sent
a postcard featuring a particular theatre and asked for the autograph
of a performer currently appearing in a production there. » ⌈FIG. 103⌉
Sometimes he even targeted the complete cast. He also sent requests
to politicians and sportsmen, and if he couldn't find a suitable picture
postcard of the person in question, he made do with one featuring a
coat of arms or relevant public building. » ⌈FIGS. 104-6⌉

Aviators held a special place in Bray's collection. He followed the
development of powered flight with great interest from the early days of
the Wright brothers in 1903 to the emergence of passenger aircraft and
highly maneuverable fighter planes. A number of aviator pioneers signed
autographs for his collection, including Herbert Rodd, pilot of the first
U.S. Air Mail; Masaaki Iinuma and Kenji Tsukagoshi, who flew the first
flight from Tokyo to England in 1937 (chilling detail: the plane's name,
The Divine Wind, means *Kamikaze* in Japanese); and Amy Johnson, the
first woman to fly solo from England to Australia. » ⌈FIGS. 107-9⌉

3 W. Reginald Bray, "Hunting Postal Curiosities," Royal Magazine, *1911, 58.*

FIGS. 95-96. Attached
to the front of these
lettercards are cigarette
cards of W. P. Frith,
a painter (ABOVE),
and Steve Bloomer, a
footballer (OPPOSITE).

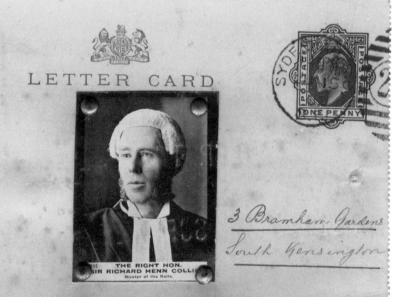

FIG. 97. On the front
of this lettercard can
be seen a cigarette card
of Sir Henn Collins,
master of the rolls,
the third most senior
judge in England and
Wales, behind the Lord
Chancellor and the Lord
Chief Justice.

FIG. 98. A cigarette card of William Ebor, archbishop of York, is attached to the front of this lettercard.

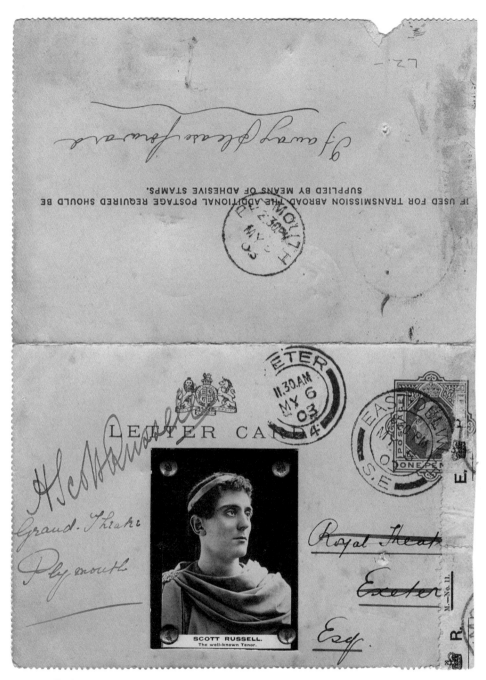

FIG. 99. This is a
lettercard with a
cigarette card of Scott
Russell, a tenor, attached
to the front.

FIGS. 100–101.
Signed picture post-
cards of (LEFT) Louis
Bradfield, an actor, and
(RIGHT) Maude Danks,
an actress.

FIG. 102. (LEFT) This
signed picture postcard
is of the actor Basil Gill.

FIG. 103. (RIGHT)
One of three identical
picture postcards, this
one was signed by the
actress Doris Beresford.
She appeared in a
production of *The New
Aladdin* at the Gaiety
Theatre in 1906.

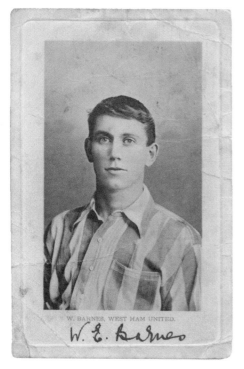

FIG. 104. (LEFT)
The signature of
West Ham footballer
W. E. Barnes graces this
picture postcard.

FIG. 105. (RIGHT)
Alexander McMillan,
British consul to Monaco,
signed a picture post-
card of the Monaco coat
of arms.

To amass such a huge collection, Bray understood that he
could not limit himself to famous people or those who had performed
only praiseworthy feats. He scanned newspapers in search of targets
who, even for a day, had become newsworthy. This inevitably included
a number of notorious characters. Amongst such signatures are those
of Horatio Bottomley and Ernest Hooley, two financial swindlers;
William Martin, the skipper of a British trawler, who attracted
criticism for *not* rescuing the crew of a sinking zeppelin during the
First World War; and Norman Baillie-Stewart, convicted of treason
and imprisoned in the Tower of London in 1933.» ⌈FIGS. 110–13⌉

Company advertisements on the backs of picture postcards
offered Bray another category of autographs to acquire. These
postcards, usually reproductions of posters or magazine adverts,
feature pictures promoting products of the day. Bray sent these directly
to the companies, requesting the autograph of a specific person in the
corporation or simply the person in charge. » ⌈FIGS. 114–15⌉

FIG. 106.
(OPPOSITE) Charles
Thomson Ritchie, MP,
former chancellor of the
exchequer, autographed
this picture postcard
of the Houses of
Parliament.

FIG. 107.(ABOVE)
This plain postcard
has the autograph of
Masaaki Iinuma, the
pilot of the first flight
from Japan to England.
The plane flew the ten
thousand miles from

Tokyo to Croydon in
ninety-four hours and
ten minutes, beating the
Tokyo-Paris record by
seventy-one hours and
forty-six minutes.

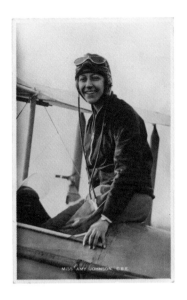

FIG. 108. (LEFT)
Amy Johnson, an English
aviator who set numerous
long-distance records in
the 1930s, also signed a
postcard for Bray.

FIG. 109. (BELOW)
The reverse of the picture
postcard, showing
Johnson's autograph.

FIGS. 110–11. A plain postcard signed by William Martin, the captain of the British trawler *King Stephen*. The accompanying newspaper article (RIGHT) describes how, in 1916, the trawler ignored pleas for help from the crew of a German zeppelin, which crashed into the North Sea after being shot down.

Skipper Martin, of trawler King Stephen, who found Zeppelin L 19 sinking, has died.

SKIPPER MARTIN'S DEATH.

MORBID BELIEF IN GERMAN VENGEANCE.

The death took place at Grimsby on Saturday from heart failure of Skipper Martin, who when in command of the trawler King Stephen on February 2, 1916, refused to rescue the commander and crew of the wrecked Zeppelin L 19 in the North Sea. After that incident he received some anonymous threatening letters from German sympathisers in this country and fell into a morbid belief that the Germans were tracking him down.

Latterly he was sustained by a passionate desire to see one of his sons who is serving in the Navy. The young man came home on special leave a week ago and, after seeing him, his father collapsed. He was 45 years of age and leaves a widow and six children.

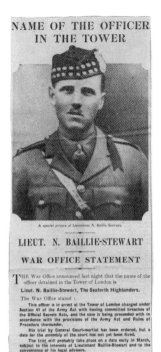

NAME OF THE OFFICER IN THE TOWER

A special picture of Lieutenant N. Baillie-Stewart.

LIEUT. N. BAILLIE-STEWART

WAR OFFICE STATEMENT

THE War Office announced last night that the name of the officer detained in the Tower of London is **Lieut. N. Baillie-Stewart, The Seaforth Highlanders.**

The War Office stated :

This officer is in arrest at the Tower of London charged under Section 41 of the Army Act with having committed breaches of the Official Secrets Acts, and the case is being proceeded with in accordance with the provisions of the Army Act and Rules of Procedure thereunder.

His trial by General Court-martial has been ordered, but a date for the assembly of the court has not yet been fixed.

The trial will probably take place on a date early in March, subject to the interests of Lieutenant Baillie-Stewart and to the convenience of his legal advisers.

FIG. 112. (LEFT)
A contemporary newspaper clipping describes the imprisonment of Norman Baillie-Stewart.

FIG. 113. (BELOW)
Norman Baillie-Stewart, imprisoned in the Tower of London for treason, signed this plain postcard.

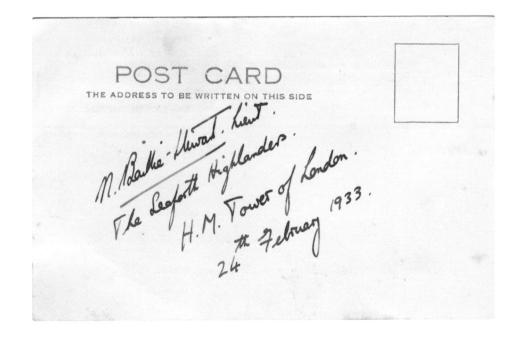

FIG. 114. (TOP, LEFT) On this picture postcard is the autograph of Albert Hildesheimer, the artist who designed the original poster advertising a brand of mineral water.

FIG. 115. (ABOVE) Henri Nestlé, son of the company's founder, signed a picture postcard advertising Nestlé's Swiss Milk.

Galvanised by his early accomplishments, especially his success in accumulating the Second Boer War autographs, Bray decided to gradually move away from postal curios and concentrate on building up a prodigious autograph collection. To achieve this he needed to increase his success rate, so, over time, he simplified the process and relied solely on plain postcards addressed to a specifically named person, with no photograph attached. He started using plain cards as early as June 1901, when he sent a request to Lord Dufferin, a distinguished Irish politician and diplomat. » ⌈FIG. 116⌉ In 1902 he sent a plain card to Ellen Stone, an American woman who was kidnapped by Macedonian bandits. » ⌈FIG. 117⌉ He also sent plain postcards to many of the military and political characters involved in the Russo-Japanese War. A spectacular success came out of these efforts: General Nogi Maresuke sent his autograph back. » ⌈FIGS. 118–20⌉

Bray also racked up some spectacular failures. Adolf Hitler proved to be particularly recalcitrant, resisting five different attempts. Each time Bray received a letter from Hitler's office politely, but firmly, refusing. In response to a rejection in July 1934, Bray sent the following reply in German:

> *Mr. Reichskanzler Adolf Hitler,*
> *Reichskanzlei*
> *Wilhelmstrasse 55*
> *BERLIN W 8*
> *Excellence!*
> *I thank you for your response 11634/VII dated July 27,*
> *nevertheless which caused me bitter disappointment.*
> *Without any patronage whatsoever, but of my own written*
> *endeavours over the last 35 years, the following personalities*
> *have honoured my requests in respect of my autograph*
> *collection: Pope Pius X, Li Hung Chang, Foch, Haig,*
> *Mussolini, von Papen, Togo, all presidents of the United*
> *States of America, Pershing, Pasitch, Kuropatkin, Briand,*
> *Joffre, Litvinoff, Stresemann, Eckener, Masaryk, etc.*

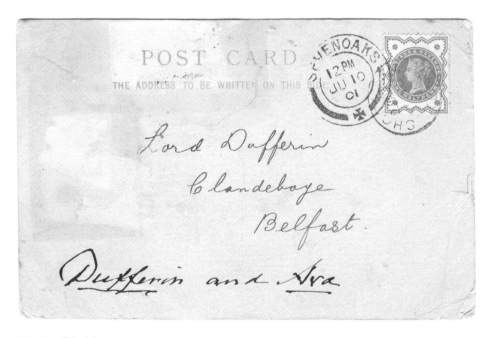

FIG. 116. This plain
postcard was signed by
Lord Dufferin, a diplomat
who became governor
general and viceroy of
India from 1884 to 1888.

FIG. 117. On this plain postcard is the autograph of Ellen Stone, an American missionary from Chelsea, Massachusetts, who achieved global fame when armed Macedonian bandits kidnapped her in 1901.

FIG. 118. A picture postcard bears the autograph of General Nogi, commander of the Japanese Third Army during the Russo-Japanese War.

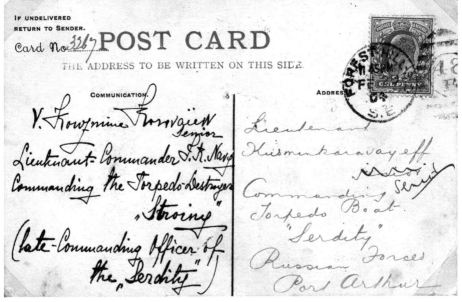

ADOLF HITLER
KANZLEI

BERLIN W8
WILHELMSTRASSE 55ᴵᴵ
FERNSPR.: A.2.FLORA 7601

DEN 6. November 1934

Herrn

 W. Reginald B r a y

TAGEBUCH-Nr. 16036/X HP
BEI RÜCKFRAGEN UNBEDINGT ANZUGEBEN

8, Queen's Garth
L o n d o n, S.E.23

Sehr geehrter Herr Bray!

 Ich bestätige den Eingang Ihres Schreibens
vom 15.v.M.

 Es tut mir leid, Ihnen auch diesmal wieder
einen abschlägigen Bescheid zukommen lassen zu müssen, da
es die zur Zeit wieder besonders starke Überlastung des Füh-
rers unmöglich macht, Ihnen Ihre Bitte um eine persönliche
Unterschrift, wie auch all die übrigen täglich hier einlau-
fenden Bittgesuche, zu erfüllen.

 Ich bedauere, Ihnen keinen günstigeren Bescheid
geben zu können und bitte Sie, von weiteren Schreiben in dieser
Hinsicht abzusehen.

Mit vorzüglicher Hochachtung!

Anlage

FIG. 119. (OPPOSITE, TOP) This plain postcard was signed by Isamu Takeshita, a Japanese naval captain during the Russo-Japanese War.

FIG. 120. (OPPOSITE, BOTTOM) Lieutenant Commander Kowjmin Karivaieff, who commanded a Russian torpedo destroyer during the Russo-Japanese War, signed this plain postcard.

FIG. 121. (ABOVE) A 1934 letter from the offices of Adolf Hitler refuses Bray's request for an autograph of the Führer.

POST CARD
THE ADDRESS TO BE WRITTEN ON THIS SIDE

POST CARD
THE ADDRESS TO BE WRITTEN ON THIS SIDE

FIG. 122. (TOP) This plain postcard was signed by Franz Bracht, senior member of the Nazi Party and mayor of Essen.

FIG. 123. (ABOVE) General Gerd von Rundstedt, a senior officer in the German Army, autographed this plain postcard. In 1940 he was promoted to field marshall and then, in 1942, he was placed in command of the Western forces. He was in command when the Allied Forces landed in Normandy on June 6, 1944.

144

I once again take the liberty to submit my autograph card in the hope of being successful. Should you still be in the possession of my card No. B 175441 dated July 16; a signature on the same would suffice.

I wish you and the German Nation all the best and remain Yours respectfully:

W. Reginald Bray

Even this rather unsubtle attempt at moral blackmail failed. Bray received the fifth, and final, rejection letter in November 1934 from Hitler's office. It stated that "our leader" was overworked and asked Bray to refrain from sending any further requests. » [FIG. 121] Despite his failure with the top man, Bray had more luck with some other high-ranking Nazis, including Franz Bracht, mayor of Essen; and General Gerd von Rundstedt, who would later be promoted to field marshall and take command of Germany's western forces. » [FIGS. 122–23]

The British Royal family also refused his requests. Bray received this official letter in response to all attempts, regardless of which royal he approached, including King Edward VII, Queen Alexandra, King George V, and Queen Mary. » [FIG. 124]

The immense number of similar applications having necessitated the establishment of a rule, that His/Her Majesty should not grant his/her autograph to ladies or gentlemen with whom His/Her Majesty is not personally acquainted.

These rejections seemed to spur Bray on, rather than discourage him. He managed to collect autographs from most of the famous film, radio, and theatre stars of his day, from early music hall and silent movie personalities to celebrities that are still household names today. » [FIGS. 125–34]

BUCKINGHAM PALACE.

The Private Secretary is commanded to express The King's regret, that the request preferred in *Mr W R Bray's* letter of the *19th inst* cannot be complied with ; the immense number of similar applications having necessitated the establishment of a rule, that His Majesty should not grant His autograph to ladies or gentlemen with whom His Majesty is not personally acquainted.

21 July 1910

FIG. 124. Letter received from Buckingham Palace informs Bray that King Edward VII would not be providing an autograph.

POST CARD
THE ADDRESS TO BE WRITTEN ON THIS SIDE

Dorothy Lamour

DOROTHY LAMOUR

FIG. 125. American film actress Dorothy Lamour autographed this plain postcard. She starred in many movies between 1936 and 1952, including the *Road to...* films with Bob Hope and Bing Crosby.

FIG. 126. Dorothy Lamour appears on this picture postcard.

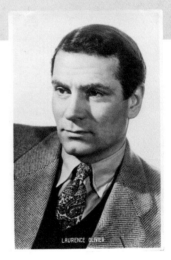

POST CARD

THE ADDRESS TO BE WRITTEN ON THIS SI

6.40 FROM THE
LONDON THEATRE—18
'Henry V'
Laurence Olivier in extracts from
Shakespeare's *Henry V*, with
Jessica Tandy and Ivy St. Helier,
now running at the Old Vic
Presented by Bruce Belfrage

LAURENCE OLIVIER

FIG. 127. The famous
British actor Laurence
Olivier signed this plain
postcard.

FIG. 128. This postcard
features a photo of
Olivier.

FROM

W. REGINALD BRAY, *The Autograph King. Unchallenged.*

Owner of the largest collection of Modern Autographs in the World.

EXHIBITOR AT—

Naval and Military Exhibition. Crystal Palace, 1901.
 do. Manchester and Leeds, 1903.
 do. Earl's Court, 1905.
International Sports and Games Exhibition, Crystal Palace, 1904 (*Diploma Awarded*).
Anglo-American Exhibition, Shepherds Bush, 1914.

Request Register No. *1858*

8, QUEEN'S GARTH,

FOREST HILL, S.E. 23

ENGLAND.

July 22 1931

Kindly add your autograph on the other side and post card to me, thanking you in anticipation.

FIG. 129. The American film actor Gary Cooper signed this pre-printed postcard.

FIG. 130. A newspaper clipping reports on Cooper's visit to London in 1930.

Bachelor Film Star.

GARY COOPER'S ONE-DAY VISIT TO LONDON.

SPECIAL "DAILY MAIL" NEWS
By WILLIAM A. MUTCH,
Our Film Critic.

A NEW record in lightning visits to London has been established by Mr. Gary Cooper, the famous film star of such pictures as "Wings," "The Virginian," and "Morocco."

Mr. Cooper, who was due back in New York on Monday, arrived in London yesterday and is to leave to-day. He has been on holiday in Italy recovering from an attack of yellow fever.

In real life he is more like his film self than almost any other star I have met, and yesterday, save for the

Mr. Gary Cooper photographed in London last evening.

fact that he was wearing a blue serge suit, he might have stepped straight from "The Virginian." He is typically and delightfully American.

When I asked him how he became a film actor, he said: "You do almost anything when you are up against it. The advertising company I was working for went broke, for which I was not altogether to blame. Then somebody told me Tom Mix got 17,000 dollars a week for riding a horse, and I could ride a horse, so I took a leap at pictures."

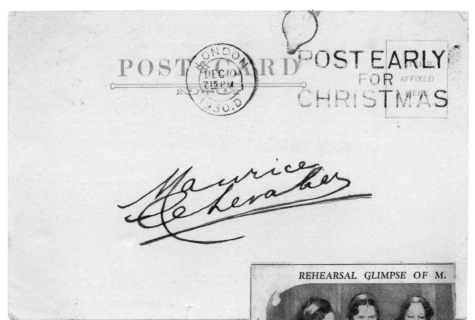

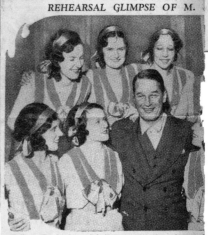

FIG. 131. Maurice
Chevalier, a French
actor, singer, and
popular entertainer,
autographed this plain
postcard.

FIG. 132. A newspaper
clipping features
Chevalier in 1930.

M. Maurice Chevalier photographed with members of the chorus who appeared
last night.

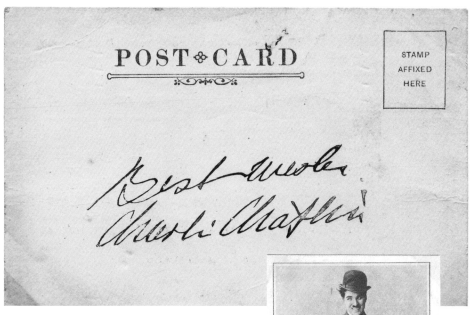

Charlie Chaplin

FIG. 133. Charlie Chaplin, the English actor famous for his roles in silent movies, signed this postcard.

FIG. 134. Chaplin appears on this picture postcard.

FIG. 135. In this
envelope Bray enclosed
an autograph request to
the marine artist William
Wyllie. The address is
specified in longitude
and latitude. It was
returned undelivered two
days after Bray sent it.

By 1904 the plain postcards had become Bray's main vehicle for collecting autographs. Over the years he changed the content and style of the back of the postcard, adding more and more information about himself and applying small changes to his message. Eventually all he needed to do was add the register number, his signature, and the name and address of the person from whom he wanted the autograph. All the other information was preprinted. Even the name and address of the recipient gradually disappeared from the postcards during the 1930s, when he began sending the cards enclosed in plain brown envelopes, with a stamped self-addressed envelope enclosed, to facilitate the autograph's return. » [FIG. 135] His efforts at streamlining the process paid off. He sent out an astonishing number—more then thirty thousand autograph requests in all—and just under half were successful.

Look at Me

Bray used the postal system for more than forty years to satisfy his curiosity into its workings and to build up an unrivalled collection of autographs. Bray's only documented motivation was to test the regulations, but his artistic talents helped him design some wonderful curios. The concept of mail art did not exist in 1898 so he couldn't have known that one day he would be considered an early pioneer. Even today only a minority of mail artists have heard of Bray, and many practitioners still refer to Ray Johnson as the father of mail art.

Even though he amassed tens of thousands of collectable items, his motives and achievements may well have gone unnoticed if he didn't also have a sense of accomplishment that he wanted to share with the world at large. » [FIG. 136] He developed a talent for writing articles about his exploits for various periodicals of the time, including the *Royal Magazine, Accountants Magazine, Answers, The Idler, Nash's Magazine,* and *Pitman's Magazine of Business Education.* Bray also ensured that the youth of his day did not miss out on his achievements. The September 1935 edition of *Girl's Own* paper and the October 1936 edition of *Boy's Own Paper* both contain lengthy articles written by Bray about autograph collecting.[1]

He was, no doubt, a gifted self-promoter. Over the years, he convinced countless newspapers to publish articles on his postal activities. Initially he would introduce himself by writing to a paper with a particular point about the postal service, but as time went by the media became familiar with him and actively sought out his story and perspective. We know this today because he kept scrapbooks full of clippings of press coverage, from small paragraphs to major features. Even French and German newspapers caught on to the Bray phenomenon and published articles about his collection.

Such was his fame that both Radio Normandy and the BBC interviewed him on their radio programmes. In June 1933 he spoke on Radio Normandy, a pirate radio station broadcast to Southern England from a transmitter in Fécamp on the French coast. And in 1935 and

1 *W. Reginald Bray, "Women's 'Writes,'"* Girl's Own Paper, *September 1935, 532–34; Bray, "Celebrated Signatures,"* Boy's Own Paper, *October 1936, 37–40.*

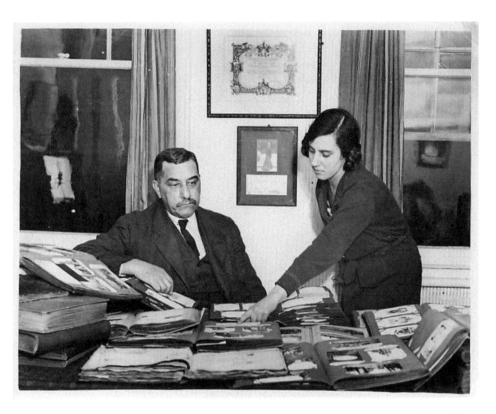

FIG. 136. This 1932 photograph shows Bray and his daughter, Phyllis, in his study at Taymount Drive, with some of his huge collection.

1936, the BBC's *In Town Tonight* programme invited Bray to be a guest on the show. A national institution, *In Town Tonight* featured famous and not-so-famous people who performed extraordinary feats. A testament to the popularity of the show, Churchman's cigarettes produced a series of cigarette cards depicting fifty of the most interesting personalities who had appeared on the programme. Card number six features Bray. He was so pleased to be the subject of a card, he managed to track down almost all of the other cards in the set signed by the personalities featured on them. » [FIGS. 137-40]

As early as 1901, Bray started to display his collection at major exhibitions. He participated in three Naval and Military Exhibitions; Crystal Palace in 1901, Manchester and Leeds in 1903, and Earl's Court in 1905; the International Sports and Games Exhibition, Crystal Palace in 1904; and the Anglo-American Exhibition in London in 1914. The last of these proved to be problematic. Bray received a letter in September of that year asking him to make immediate arrangements to disassemble and retrieve his exhibit due to the outbreak of the First World War. » [FIG. 141] Perhaps this last exhibition was enough for him; there are no records of him participating in any other similar activities.

Surely his preprinted postcards, sent out as autograph requests, functioned as his most prolific and powerful publicity tool. Starting with a simple card featuring his address in 1901, he gradually developed the idea of using the back of the postcards to promote his achievements. By 1939 he had perfected the design, including a list of all his exhibitions, the appearances on the BBC, and his claim to the title of "The Autograph King." Leslie Whitton, the "Scottish Autograph King," signed the last known of these cards in March 1939. This is the only card discovered to date that features Bray's Croydon address, his last. » [FIG. 142]

FIGS. 137-38. (OPPOSITE AND OVERLEAF) The front and back of a signed Churchman's cigarette card featuring Fred Archer, "The Living Wax Model."

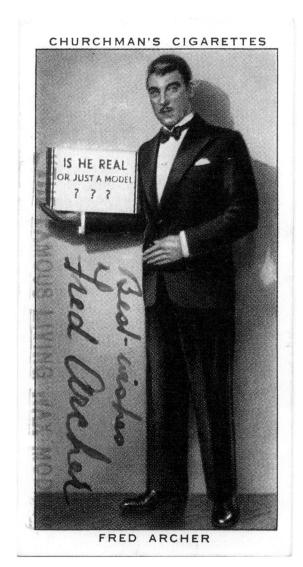

ALBUMS FOR CHURCHMAN'S PICTURE
CARDS CAN BE OBTAINED FROM
TOBACCONISTS AT ONE PENNY EACH

"IN TOWN TO·NIGHT"

A SERIES OF 50

1

FRED ARCHER
Living Wax Model

After twenty years in the motor trade, Fred Archer decided he would like a change, and being impressed by the idiotic expressions worn by dummies in shop windows, he conceived the idea of a living wax model. After twelve months' practice and study of models' "habits," aided by experience of sentry duty in the Grenadier Guards, he can now remain perfectly still without blinking for 35 minutes, and sits in shop windows deceiving the most critical onlooker by his immobility. Suddenly, to the great amazement of the crowd, the "wax model" relaxes and becomes a human being once more. Mr. Archer also occasionally works at the film studios.

W.A.& A.C.CHURCHMAN

ISSUED BY THE IMPERIAL TOBACCO CO
(OF GREAT BRITAIN & IRELAND), LTD.

160

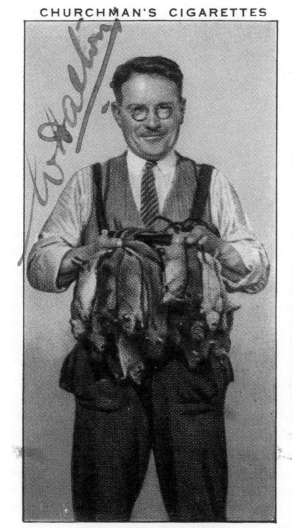

CHURCHMAN'S CIGARETTES

WILLIAM DALTON

FIG. 139-40. (ABOVE
AND OVERLEAF)
This signed cigarette
card from the *In Town
Tonight* series features
William Dalton, the "Rat
Catcher."

ALBUMS FOR CHURCHMAN'S PICTURE
CARDS CAN BE OBTAINED FROM
TOBACCONISTS AT ONE PENNY EACH

"IN TOWN TO-NIGHT"

A SERIES OF 50

11

WILLIAM DALTON
Rat Catcher

Partner of the famous firm of rat
catchers, established in 1710,
Mr. William Dalton claims they
are always busy. The rats are
caught at night without the use
of dogs, ferrets or poison, but a
certain amount of work during
the day is necessitated by the
repairing and setting of traps,
which cannot always be accom-
plished at night time. The rats
are all caught alive by a secret
method, the record catch being
1,600 rats caught in one night by
only three men, in the Romford
area. The skins to-day are of no
commercial value, but during the
Great War they were sold at 5d.
each for use in the making of fur
coats.

W.A. & A.C. CHURCHMAN

ISSUED BY THE IMPERIAL TOBACCO CO.
(OF GREAT BRITAIN & IRELAND), LTD.

TELEPHONE: PARK 300
TELEGRAMS: "SHEPEXIAN, LONDON."

ANGLO - AMERICAN EXPOSITION,
LONDON (MAY TO OCT.), 1914.

TO CELEBRATE THE CENTENARY OF PEACE AND PROGRESS IN THE ARTS,
SCIENCES, AND INDUSTRIES OF THE UNITED STATES OF
AMERICA AND THE BRITISH EMPIRE.

Patron
His Royal Highness
THE DUKE OF CONNAUGHT.

Hon. President
His Highness
THE DUKE OF TECK.

Vice=Presidents
EARL CURZON OF KEDLESTON.
THE EARL OF DERBY.
EARL GREY, President British American Peace Centenary Committee.
VISCOUNT BRYCE, P.C., O.M.
LORD ROTHSCHILD.
LORD WEARDALE.
THE LORD MAYOR OF LONDON.
SIR ARCHIBALD GEIKIE, O.M., Past President Royal Society.
THE RT. HON. SIR WILLIAM MATHER, P.C., President British Science Guild.
SIR EDWARD J. POYNTER, Bart. President Royal Academy.

American Vice=Presidents
NICHOLAS MURRAY BUTLER, President Columbia University.
HON. JOSEPH H. CHOATE, New York, Formerly Ambassador to the Court of St. James's.
FREDERICK P. FISH, Boston, Mass.
JAMES B. FORGAN, Pres. First Nat. Bank of Chicago, Ill.
HON. DAVID R. FRANCIS, Ex-Governor Missouri, President recent International Exhibition, St. Louis, Mo.
ALBA B. JOHNSON, President Baldwin Locomotive Works, Philadelphia, Pa.
ABBOTT L. LOWELL, President Harvard University.
SAMUEL MATHER, Cleveland, Ohio.
J. G. SCHMIDLAP, Cincinnati, Ohio.

Director General
IMRE KIRALFY.

Executive Committee
THE EARL OF KINTORE, P.C., G.C.M.G., Chairman.
LORD BLYTH, Chairman Organizing Committee.
HON. SIR JOHN A. COCKBURN, K.C.M.G., Vice-Chairman, Chairman Overseas Committee.
SIR ARCHIBALD GEIKIE, K.C.B., O.M., P.P.R.S.
THE RT. HON. SIR WILLIAM MATHER, P.C., P.B.S.G.
SIR EDWARD J. POYNTER, Bt., K.C.V.O., P.R.A.
LORD ROTHEDHAM, Chairman Reception Committee.
HON. ARTHUR STANLEY, C.V.O., M.P.

CHARLES L. KIRALFY, } Commissioners
ALBERT E. KIRALFY, } General.

AACL/K

General Offices: Administration Buildings,
Shepherd's Bush,
London, W. (England).

9th September, 1914.

Wm. Reginald Bray, Esq.,
8, Queen's Garth,
Queen's Road,
Forest Hill, S.E.

Dear Sir,

I am directed by the Executive Committee to inform you that, owing to the position created by the war, they would feel much obliged if you would make immediate arrangements for sending for the exhibits which you so kindly lent them, and which have been so much appreciated by the visitors to the Exposition.

Yours faithfully,

[signature]

FIG. 141. This letter informed Bray that he needed to retrieve his exhibit from the Anglo-American Exposition as soon as possible, due to the outbreak of war.

163

POST CARD

THE ADDRESS TO BE WRITTEN ON THIS SIDE

Yours sincerely,

Leslie M. Whitton,

"Scotland's Autograph King."

7/4/39.

FIG. 142. A postcard signed by Leslie Whitton, "Scotland's Autograph King," was one of the last autographs Bray collected shortly before his death in June 1939.

Bray died on June 6, 1939, at his home in Croydon, Surrey. His daughter, Phyllis, eventually decided to sell off the vast collection of his items in the 1950s. Whilst it is not entirely clear how the collection was finally disposed of, it appears that most of it was purchased by a single buyer. However, there are stories circulating amongst collectors that the Bray collection was sold off in lots of one cubic foot to prevent any one person from acquiring the lion's share. This may have been the fate of the remainder after the initial sale in the 1950s, or the means by which the original purchaser disposed of his hoard. Or perhaps it is just a good story. Most, if not all, of the participants of the original sale are no longer with us, so the details remain a mystery. What we know for sure is that the wonderful group of postal curios and the greatest collection of autographs in the world were broken up and dispersed throughout the collecting community.

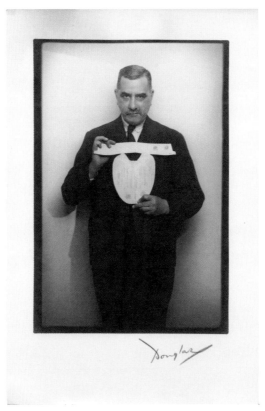

1938

Bray's optimism and persistence—perhaps an equal share of each—propelled him forward in the face of obstacles and rejection, and compelled him to find inventive ways to get around bureaucratic regulations and road blocks. He pioneered a mail art project that bridged two centuries, enlisting postal carriers and unsuspecting finders of his creations as his collaborators. Piecing together his life's work has, fittingly, tapped my own strain of optimism and persistence. Starting with no more than a few miscellaneous cards and very little bio-graphical information to go on, I have watched his legacy slowly but steadily emerge from the shadows. Though collectors around the world can account for only a fraction of Bray's items, I trust that many more will come to light in the years ahead, each one providing us with another clue to the story of this most unusual Englishman.

ACKNOWLEDGMENTS

The best way to tackle this section is chronologically, so let me start at the beginning. The first person I want to mention is Steve Grindlay of Forest Hill, whose web page about Bray set me on the first steps of this research expedition.[1] Steve sent me images of his own cards and photos of Forest Hill, and even gave me a guided tour of Bray's old neighbourhood. Without Steve this book would never have been written.

Next must come John Baron, a friend and fellow member of my stamp club. John has continually supported me in my endeavours to build both my collection and knowledge of Bray and even plays the part of Bray himself when I give talks to other stamp clubs. He spent one very tiring Sunday with me at the postcard fair in Reading talking to dozens of dealers to see if anyone had any Bray items for sale. John discovered the dealer Julian Dunn, who sold me a hoard of cards that really kick-started my collection. Julian has kept an eye open for Bray items ever since, and he has supplied some of the cards and curios featured in this book.

I must say thank you to some fellow philatelists who have lent me visuals for my website and this published collection. Whilst all the images are individually acknowledged, I would like to make a special mention of James Grimwood-Taylor, Michael Pitt-Payne, and John Forbes-Nixon.

I reserve a small mention for Steve Greenfield and Ray Brown, two friends who have absolutely no interest in stamp collecting but have been enthusiastic supporters of my developing interest in Bray. Many a happy lunchtime we've spent down at the local pub looking at my latest discoveries. In fact, they were keen for me to write a book long before a publisher came into my life.

I cannot even begin to estimate the importance of the help provided by Bray's granddaughter, Zoë James. Zoë has been absolutely superb in learning how to provide high-quality scans and subsequently sending me pictures of all the cards, clippings, photographs, and letters she inherited from her mother. She has also told me much about Bray and his family that I could not have found out from anyone else. Zoë's daughter, Nicola James, has been of immense help as well. Nicola invited me to visit her in Penge and borrow her pile of cards

1 Steve Grindlay, "W. Reginald Bray, Autograph King," http://sydsoc.org.

and newspaper articles to help build a more complete picture of her great-grandfather.

I would also like to say a special thank you to Michael Leigh, the mail artist who not only sold me the original Bray strip cartoon that he drew in 1989, but also informed Sara Bader at Princeton Architectural Press about my website. Soon after, Sara emailed me and suggested that I might consider writing this book. Sara's patience, support, and skill helped me create a proposal that Princeton Architectural Press decided to publish. And a sincere thank you to Deb Wood, who translated the material visually and created a beautiful design for this book.

Last, but by no means least, is my wife, Ann, who brilliantly put up with me during this period when I have become almost obsessed by Bray. Ann spent hours sitting at her computer trying to help decipher strange autographs and searching the Internet to find out more about the people who signed and returned Bray's requests. On more than one occasion she came home from work to find the dining room table covered with cards, album pages, and reference books as I tried to piece together my collection and exhibits. To Ann I must say, thanks.

Of course, this is not a complete list, so I humbly apologise to anyone I failed to mention. As you can see, this book would not have been possible without the support, encouragement, and contributions from a number of people.

This book is dedicated to the other great "W. R." in my life, my late father, William Roland Tingey. Like Bray, he preferred to use his middle name rather than his first, although in his case he liked to be known as "Ron." Sadly, Ron passed away a few short weeks before I learned that Princeton Architectural Press would publish this book. He was a wonderful father and friend, fully supportive of all of my endeavours. I know that he would have been proud to see the results of this journey of discovery. He balanced many careers, but perhaps his service in the Grenadier Guards defined his character the most. It was this experience that shaped him into a role model as a father, as well as a loving and caring husband. Ron was a true English gentleman and a very gentle man.

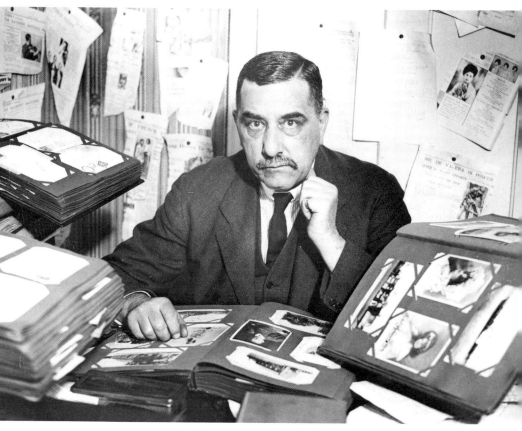

1932

BBC News, "Will It Be Safe in the Post?" December 19, 2000,
 http://news.bbc.co.uk/1/hi/uk/1076816.stm.
Bray, W. Reginald. "Postal Curiosities." *Royal Magazine*, 1904, 136–142.
———. "Hunting Postal Curiosities." *Royal Magazine*, 1911, 58–61.
———. "Postal Freaks and Postal Facts." *Post Annual* (1931): 35–40.
———. "Making an Autograph Collection." *Hobby Annual* (1933): 123–126.
———. "Postmarks." *Post Annual* (1934).
———. "Women's 'Writes.'" *Girl's Own Paper*, September 1935, 532–534.
———. "Celebrated Signatures." *Boy's Own Paper*, October 1936, 37–40.
Grindlay, Steve. "W. Reginald Bray, Autograph King." Sydenham Society. http://sydsoc.org.

SEE PAGE 12

All images are from the author's collection except for the following:

Chris Aucamp: 110–11
The British Postal Museum & Archive: 27
Cavendish Philatelic Auctions Ltd.: 51, 56 (bottom)
Kenneth G. Clark: 141, 142 (bottom)
John Forbes-Nixon: 39 (top), 67 (bottom), 71
John Griffith-Jones: 96
James Grimwood-Taylor, M.A.: 48–49, 57, 88, 124, 164
Steve Grindlay: 127, 131 (right), 137 (right)
Bryan Horsnell: 125
Nicola James: 35, 77, 80, 136, 143, 144
Zoë James: 6, 8, 23, 25, 28–29, 36, 78, 81, 104, 119–20, 134 , 146, 147 (top), 148 (top), 149–50, 151 (top), 157, 159–63, 166
Steve Marsh: 131 (left)
Michael Pitt-Payne FRPSL: 38, 53–54, 56 (top), 64, 66, 70, 74, 85, 117
Tony Roberts: 113
Ian Shapiro: 118 (top)
Soler y Llach: 116
Morris Taber FRPSL: 97–98
Rev. Richard Thornburgh: 130 (left)